PRICING PHOTOGRAPHY

The Complete Guide to Assignment and Stock Prices

by

Michal Heron
David MacTavish

 ALLWORTH PRESS, NEW YORK

lectors and museums, a specialty unto itself, crosses over into all aspects of photography. Art can originate in any part of the business. Pricing of fine art photography is determined by the power of the work, the reputation of the photographer, and the skill of the gallery.

The pricing and negotiating techniques in this book will concentrate on photography for publication.

Photography Career Choices

How do you earn your living as a photographer? Life-style preference and circumstance (like what jobs are available) will largely determine whether a photographer works on staff as an employee or on their own as an independent businessperson/entrepreneur.

Staff photographers are used by companies as varied as newspapers and book publishers or medical audio-visual producers, as well as institutions ranging from museums to governmental agencies—actually, wherever an institution has a large enough volume of work to keep a photographer busy.

Staff jobs generally pay a relatively low salary but offer the security of a regular income, benefits, access to expensive equipment without the overhead of maintaining it, and an opportunity to gain practical experience in a variety of photographic areas. Staff jobs can also provide continuity, often offering the photographer the opportunity to work with the same people or on the same types of projects, and sometimes even to become a specialist in one field.

Being an independent photographer means you are in business for yourself whether you work as a sole proprietor (just you) or run a photography studio with a full staff. This lifestyle offers variety, creative challenges, the possibility of a higher income than a staff position—and fear. Along with the excitement and satisfaction of running your own operation comes the pressure of maintaining an overhead with an uncertain income flow. A word about words: the term freelance is widely used to describe the independent photog-

rapher and is just as widely misunderstood, even by photographers themselves. The dictionary meaning is clear but narrow: "someone who works in a profession, selling work or services by the hour, day, or project rather than working on a regular salary basis for one employer."

The word is often misused and sometimes given the unprofessional connotation of working with a rather casual commitment to one's profession, "Oh, you're a freelancer, how nice, you can work when you feel like it...," while to others it is a merely a euphemism for being out of work. Freelance can also conjure up the romantic image of a foot-loose photojournalist, trench coat flapping, camera bags swinging, as he or she boards the last helicopter out of today's trouble spot.

What the word does not properly convey is the sense that photography is a business and photographers are businesspersons. All of this etymology has a point. The words used reflect the way photographers think of themselves; the sooner photographers recognize that in addition to being creative people they are also businesspeople, the more likely it will be that success and contentment will follow.

The information in this book is critical to the financial success of an independent photography business. But it is equally (and perhaps more) useful to the staff photographer who sells stock or does the occasional freelance job. The staff person, being out of the mainstream of day-to-day pricing, may be more at sea when called upon to negotiate an assignment or stock photo sale.

Photography Income

The two main sources of photography income for the independent photographer working for publication are:

- Assignment photography

- Stock photography

Assignment photography is new photography, commissioned and paid for by a client. We photographers are selling our ability to create a photograph and also the rights for the client to reproduce that photograph for a very specific usage and time period.

In stock photography we are selling (licensing) rights to reproduce an already existing photograph. Those stock photographs are any to which the photographer owns the rights. They may have resulted from many sources, from an assignment (the outtakes—the images that weren't used by the assigning client), from photography produced specifically with stock in mind, or from any other impetus such as travel shooting, family portraits, or lighting experiments. Any good photography to which you own the rights is potential stock photography.

Stock photography can be marketed for us by one or more professional stock photo agencies to a range of clients worldwide. Photo agencies maintain a staff to handle everything from the routine filing of the images and paperwork to the development of sophisticated new technology for electronic marketing. To cover these costs they keep a commission from any fees they collect for usage licensing (commonly 50 percent). They do not own the copyrights but merely act as agents on our behalf. The alternative is for the photographer to handle the entire marketing of stock through his or her own business. (For thorough coverage of this complex industry, consult the books listed in the Bibliography.)

What Are We Selling?

Photographers offer a service made up of many intangibles including a creative eye, technical ability, an array of complicated equipment, the logistical skills to plan and produce a shoot, an ability to hire and manage assistants, stylists, or location scouts, and perhaps the most important of all, intelligence. A client is buying the brain behind the camera, the keen insights of a well-informed mind; in-formed on the newest equipment in photography, informed on stylistic trends, informed on business and world events.

Time is **not** what photographers sell; you'll find this as a continuing theme throughout this book. Calculating the time spent taking a photograph as the sole or principal value of your photography is foolhardy. It reduces your contribution to that of a day laborer and totally ignores the creativity and expertise you bring to a shoot.

So, what are we selling? A photographer's ability to translate the client's message into a powerful graphic statement is the service being offered. And, the **usage rights** to the resulting photograph(s) are what's being "sold." These are key points for photographers to understand and then to communicate to clients.

The value of copyright

The most important asset you have is the copyright in your photographs. Once you have brought to bear all the talents listed above, the tangible result, the photograph, has a life of its own. The right to reproduce it, which is called the copyright, is the primary asset of the photograph.

An understanding of copyright is integral to your success as a photographer. You should protect your copyright with a copyright notice (© symbol, name, date of first publication), and for greatest protection, register your photographs with the copyright office in Washington, DC. We urge you to read more detailed coverage on copyright in some of the books listed in the Bibliography. But for now, here are the basics.

The copyright is actually composed of a bundle of rights which can be separated and portioned off for different purposes, and licensed to a variety of clients for a wide range of fees. The same photograph has a virtually unlimited number of uses over its lifetime. Under the law, the copyright belongs to you from the moment of creation: the moment the shutter clicks and the image is fixed on

the film. The only exceptions to this are, if you are an employee, or, if you have signed a "work for hire" contract with a client.

If you are an employee, and unless you've made a special arrangement to the contrary, the copyright in any photograph taken on the job belongs to the employer. However, the copyright to any work done on your own time, vacation or weekends for example, is yours.

The other exception to your ownership of copyright is an aspect of the law called "work for hire." You will lose your copyright (by literally giving it away) if you sign a work for hire contract with a client. This has become a major problem in assignment work when clients request, or often demand, work for hire as a condition of obtaining the assignment. Stock photography can never be considered work for hire.

By signing a work for hire contract you are giving up all your rights in the photograph(s) and all future income from them. Under the law, work for hire assumes that the client, not you, created the photograph. They (the client) receive all the fruits of your labor and your creativity. This dreadful, onerous aspect to the law should be stringently avoided. (See page 10.)

It's easy to see that work for hire will erode your future income and strip you of creative control of your life's work. But, there are many ways to skin this cat. Be aware that a client who wants to accomplish almost the same end may simply demand all rights, a buy-out or a transfer of copyright, all of which may have a similar devastating economic effect on you. So, whatever the terminology used in the effort to take it away, the value of your major asset, the copyright in your photographs, must be protected.

Congress gave something special to creators through the protection of copyright. Use it.

The History of Pricing

The traditional industry practice for photographic assignments is that the client pays a photography fee, plus all expenses related to the shoot, in exchange for which they get specific usage rights to the photography. The client's investment in new work is protected from use by competitors by the photographer granting restrictions, either by holding all outtakes from stock sales until the assigning client's needs are met or withholding their use by the client's competitors forever or for a certain period.

The payment for use of stock photography is for specific reproduction usage. There are other fees the client pays which cover some of the cost of submission, such as research or holding fees, but clients do not pick up the specific expenses connected with the shoot. (More about these points in chapter 2.)

Historically, pricing levels have been different in each segment of the industry—advertising, corporate, and editorial.

Advertising paid the highest fees. These rates were influenced primarily by the size of the advertising budgets for the purchase of space in which to display the ad, and as well by the perceived importance (by the client) of the photo in relation to the ad. In advertising the photographer usually remained anonymous; photo credits were, and still are, thought to distract from the advertiser's message.

Corporate clients paid fees only slightly lower than advertising clients. They placed great importance, and therefore money, on the value of first class photography to their annual reports and brochures—publications which represent the corporation to the public. They usually required a very high level of creative lighting and technical skill.

Editorial clients, newspapers, magazine and book publishers, tended to have low budgets but offered what was perceived as interesting, meaningful work—assignments to document the influence of industrialization on the Indians of the Brazilian rain forest, for example. Photo credits, seen as a form of promotion for the photographer, were offered in part to offset the low fees.

There were technical aspects to this pricing disparity as well. In the past, editorial fees were lower partly because the technical demands and expectations from a client were lower. Therefore less expensive equipment was required. Advertising and corporate clients, however, demanded high production quality, which was expensive to deliver.

Changes in the business

Twenty years ago the casual perception was that to be an editorial photographer all you needed was "a couple of Nikons and some fast film." At that time, advertising photography was characterized as a business of large productions in a studio with set constructions, legions of assistants, models, and stylists, using zillions of watt seconds of strobe light with an 8-by-10 inch view camera.

Things have come full circle. Today's editorial shoot often requires sophisticated lighting, models, and sometimes sets. It may be more production/illustration than traditional documentary/editorial. At the same time, the advertising pendulum has swung; the style sometimes mimics the gritty look of real life instead of the polished perfection that once was standard. The scenes and models are still carefully controlled and of high production quality, but shot with a grainy film, and staged to create the feel of spontaneity.

The stylistic distinctions are becoming blurred, the technical demands are equal but the fees have not reflected these changes. And this at a time when photographs are an increasingly powerful method of selling goods and services.

Pricing today

It's no secret that the economy of the past few years has been sluggish, and that's saying it kindly. The world of photography has been hit at least as hard as the national economy. There are many factors. The mergers of the 1980s meant a shrinkage in clients across the industry— from advertising agencies and publishers to corporations. Photo budgets were cut and projects canceled. Add to this the ever-increasing number of photographers emerging from schools across the country. There was also the perception that the magical technology of the new cameras made skilled professionals unnecessary for many photo needs.

The cold fact is that photography prices have been pretty much stagnant for about ten years while costs have risen dramatically. There has been pressure downward from budget-slashing clients, often with no corresponding push upward on the part of photographers. This is as foolish as when companies cut ad budgets because their sales are down. But that's the reality.

Importance of pricing

But doom and gloom is not reality. Successful new businesses were started even in the depths of the great depression of the 1930s. There is always room for new photographers with fresh energy and ideas. Experienced pros can weather the economic hard times through skillful promotion of their vision and business. What won't work is to turn tail and run, cutting prices as you go. Many photographers still think they can demolish competition by undercutting fees, but eventually find they will only be left with their own business in ruins. Accelerating a downward spiral, by matching low prices, will result only in driving you and your colleagues out of business.

Where These Prices Originated

The prices in the charts, later in this book, have come from a wide range of professional photographers and stock photo agents across the country and at different levels in the profession. They are intended to give you a starting point for negotiation and a guide to industry practices.

What This Book Is About

This book is based on the assumption that you have the necessary knowledge of photography to create handsome, meaningful photographs. The creative, technical, marketing and production skills or legal information you need to run a successful business are not covered. For that, consult the many useful books listed in the Bibliography.

The purpose of this book is to help you understand how much you need to earn to stay in business, and how to calculate and negotiate the specific prices that will allow you to earn the amount you need. By simplifying the process of pricing, you will have more time and creative energy for your photography. In a happy sort of ellipse, this in turn will give you greater income to invest back into the business, allowing you to savor, even more, the joy of photography.

Work For Hire

Work for hire means that the assigning client has become the creator, instead of you, and that the copyright vests in the client from the moment of creation; it's as if you never existed. And this applies to every photograph taken during the assignment, not just those used by the client.

Work for hire can only exist:

- if you and the client have signed a work for hire contract and,

- if the type of work falls under one of nine categories listed in the law, the most relevant to photographers being:

 contribution to a collective work such as a magazine,

 as part of an instructional text,

 as part of a supplementary work—a smaller work created to go with and supplement a larger work,

 as part of an audiovisual production, or

 as part of a motion picture.

The effect of work for hire is that you are made into an employee for the duration of this project, but you are not given the benefits a staff employee enjoys, such as health insurance and paid vacations.

The results of work for hire are:

- loss of authorship—the client becomes the creator,

- loss of creative control over future use of the photograph,

- loss of control or use of any photographs taken during the assignment,

- loss of residual income from the photograph,

- loss of future income for your retirement or your estate,

- loss of bargaining power,

- absence of employee benefits, and

- no rights to authorship credit.

Not only do you give up all of this but you must face the possibility that you may be competing against your own work some day. The client, now the copyright owner, has not only unlimited use and control of the photographs, but can also sell them, just as a stock agency would, with no payment to you. And, yes, they can even give these photographs away for free! It has happened. Can you or your stock agent(s) successfully compete when someone else is giving away your work?

Chapter 2

The Economics of Photography

There is an interesting truth that photographers (and perhaps all creative people) should commit to memory. And that is, photographers can be artistically successful with a moderate amount of technical knowledge, but they can *only* be financially successful by learning, honing, and applying business skills *as much or more* than they do artistic ones.

On Being a Businessperson

Many creative people look at business as an evil to be shunned or ignored, and far too many photographers take some sort of perverse pride in boasting of their lack of business acumen. Too bad. Business dealings are a necessity for the developing photographer unless you are content to remain a hobbyist; frankly, business can even be fun. Treat establishing and maintaining your business as a goal worth achieving, because it is. You, and your family will be the winners—there are no losers.

A businesslike approach will go a long way towards dispelling any unstated anxieties your clients may have, whether it is their stereotypical ideas about creative individuals being sloppy businesspeople, or simply wondering if you are really competent to handle a complex assignment.

Doing What You Like

While the different types of photography—advertising, corporate, editorial, and stock—each generate varying degrees of income, making money shouldn't be the major determinant when deciding what field to concentrate on. Generally, you will be happiest doing what you like and what you're good at, rather than just trying what may pay the highest fees.

This chapter will help you understand:

- What you need to earn to stay in business: determining the amount which will cover your basic business and personal needs, and also provide for company growth, and

- What goes into pricing: what the elements are that you must consider as you determine a price, be it stock or assignment photography.

How You Earn: Assignment vs Stock

This book deals with photography that is intended to be published in some manner. Mostly, your work will appear on the printed page, but increasingly photographers will find non-traditional publishing forms—like CD-ROM disks—to be profitable.

The two basic disciplines in publication photography are: assignment and stock.

Assignment photography can be appealing because it is an opportunity to create new work. It provides the challenge of working with different people and the stimulus of shared ideas as you work together to solve their visual problems. It also offers the in-

viting benefit of knowing there will be an immediate financial reward. For the client, commissioning assignments provides the opportunity of fresh, never-before-published work for their project.

There can, however, also be a great deal of risk. For the client, risk from having to pay out money without first knowing exactly what the results will be. The photographer, on the other hand, is constantly gambling that all of the preparations, equipment checks, model selection, and lighting design for an assignment will work out as planned, and that the final images will contain the drama and excitement envisioned at the outset.

Stock photography offers an alternative to the pressure of assignments, something that some photographers opt to avoid. Instead stock photography provides the same opportunity to produce exciting work without many of the limitations presented by clients. You are free to create photographs as you see them. And, no client bookkeeper will restrict your creativity by nagging about budgetary discipline.

This doesn't mean, however, that stock photography allows total and unbridled freedom. You, not a client, will be fronting the expenses of photography, and financial rewards may not appear for many years. Therefore, to make a go of stock, you must paradoxically be even more strict than any client in controlling time and costs. The risk for you will be in producing photographs that clients will wish to use, and pay to use. Many photographers find that a blend of assignment and stock provides a satisfying combination, each complementing and rejuvenating the other.

What Are We Pricing

12

Prices are based on certain industry wide assumptions, whether for stock or assignment. First, the larger the project budget (and therefore the value to your client), the higher the possible fees. And second, the size of the usage and number of uses directly affects what a client should pay.

In other words, because advertising projects generally have the largest project budgets (and the most potential for realizing profit), larger fees are usually paid. And, if a client wants to use a photograph on a billboard, a package, and as a two-page spread advertisement, they will pay more than if they had used it only on the package.

Day rate vs. creative fee

Traditionally, photographers priced their work using a "day rate," and typically priced jobs as "day rate plus expenses" for each billable day.

A billable day was usually considered to be any day during which photography actually took place. If there were multiple days, the number was multiplied against the day rate for a total. This approach worked somewhat well for decades, although it didn't accurately reflect the real values of the assignment or the photographer's talents. And, it brought about some friction with photo buyers.

Too many buyers, when confronted with the term "day rate," react negatively, comparing a day rate to the eight or so hours they toil daily. They probably don't realize that you may have fewer than one-hundred billable days per year, or that each billable day you are about to work for them will take at least an additional day for pre-production and possibly another for editing, preparing the photographs for delivery, and so on. And, they probably aren't aware that your fee goes to help pay for overhead, items like insurance, health coverage, and the many things they take for granted as employees.

Conceived during the heyday of magazine photojournalism the concept of "day rate," in today's marketplace, is philosophically and financially unwise. Do yourself and your client a big favor. Quote a "Creative Fee" for the assignment, and not a "day rate."

A Creative Fee encompasses much more than the simplistic day rate, and consists of: Overhead (what it costs you to be in business each billable day), a Profit (usually expressed as a percent-

age of overhead), and, based on the particular assignment, other relevant factors of value (like time, experience, hazards, value to the client, and so on). The grand total will be your Creative Fee. The theory of "day rate," by comparison, doesn't account for any factors other than time. (Note: expenses related to the assignment are not included within the Creative Fee but are usually listed as separate items.)

At first glance, it may seem easier to use the concept of day rate, since it is easily quantifiable and understandable. The other argument usually tendered, that it may be a safer method if your authority over an assignment, is limited. What if you incorrectly calculated and additional time is required to complete the assignment, some may ask? If you estimate by using a Creative Fee, their reasoning goes, you might find yourself working extra days without pay. The simple solution is to note in your estimate or bid that "...the Creative Fee assumes a specific time period..."; a range within which you feel you can do the photography, possibly one you've already agreed to based on discussions with your client. "Should extra time be required...," your terms and conditions continue, not of your own causing, you "...will have to revise the Creative Fee accordingly." (See Bibliography for information about paperwork that will protect your position.)

Clients will commonly ask for your "day rate." It's best to tell them that quoting a day rate is not the way you work because you price by the job, and quoting any rate is impossible without knowing all the factors of a job. Why not say instead, "If you care to tell me about an assignment you recently did, or an upcoming one, I'll be glad to give you an idea of what my Creative Fee would be." This approach has two benefits. Not only are you able to offer a more accurate idea of price, you also have them involving you in discussions directly related to assignments.

Elements of an assignment price

In assignment photography it is important to remember that all costs associated with production are borne by the client in exchange for the first use of the image(s). Therefore, the elements that constitute the assignment's bottom line price are:

Creative Fee: compensates for overhead, profit, and time, including that for photography, and also intangibles like experience or special skills. Some photographers include in the Creative Fee a modest amount of time for pre-and post-production, such as phone calls to arrange the assignment, casting, or meetings. It could be said that the Creative Fee can be formulated as: Overhead plus Profit, divided by the number of possible photography days you expect in a year, multiplied by the number of days in an assignment, added to various usage factors. It could be drawn as:

Creative Fee =				
Overhead + Profit	÷	Annual Photography Days	x Assignment Photography Days +	Usage Factors

Other elements of the Creative Fee include:

Usage Rights: factors based on how the client intends to use your image(s).

Re-Use Fees: e.g., when a client reuses your assignment photographs. If negotiated at the time of the original assignment, additional use is usually part of the Creative Fee. If done at a later date, these fees may be negotiated and invoiced as Re-Use Fees, similar to stock reproduction fees.

Other Fees: are billed as incurred. Significant pre and/or post production time, casting time, travel time, and weather delays are traditionally all billable.

Assignment Fees and Expenses

The checklist below contains many, but not all, of the fees and expenses traditionally billed for assignments. When estimating be sure to include any that are applicable.

Fees

Photography

Creative Fee	Re-Use Fees

Non-Photography (for others see Expenses)

Pre/Post Production	Travel	Casting
Weather delays		

Expenses

Casting

Director	Transportation	Film
File usage (use of information from)		

Crew

Assistants	Home Economist	Security
Wardrobe stylist	Prop Stylist	Model maker
Makeup/hair stylist		

Insurance

Liability	Binders/riders	Special

Film/Lab

Film	Processing	Polaroids
Prints (any)	Proofs	Stats
Special charges		

Location

Transportation	Labor	Scout
Customs/carnets	Mileage/park/tolls	Permits
Car/truck rental	Usage/rental	Gratuities
Air freight/baggage	Camper/dressing room	

Messengers/shipping

Messengers	Shipping	Trucking
Overnight express		

Props

Purchase	Rental	Food
Preparation	Stylists (also see Crew)	

Rental

Lighting	Lens	Camera
Filters	Special effects	Overtime

Sets

Carpenter/painter	Home Ec supplies	Design
Hardware/lumber	Product prep	Paint/walls
Backgrounds	Set Strike/labor	

Studio

Rent—build/strike	Rent—shoot	Overtime
Power/light	Telephone	Supplies
Storage		

Talent

Billed direct	Billed to studio	
Adults	Minors	Extras
Fitting (clothing)	Animals/trainers	Overtime
Per diem	Hotels	Meals
Air fares		

Transportation (local)

Car	Bus	Subway
Parking	Tolls	

Travel

Per diem	Hotels	Meals
Air fares		

Wardrobe

Purchase	Costume designer	Rental
Seamstress	Wigs/makeup	

Miscellaneous

Gratuities	Long distance phone	Meals/catering

Expenses: usually any costs incurred during the production of the assignment and that are directly related to it are billed to your client.

Miscellaneous Charges: Expense Mark-Ups should be incorporated into your expense charges to compensate for the use of your money until you are paid. If your client expects you to extend them "credit" on expenses, you should expect to be paid for it.

Postponement, Cancellation and Re-Shoot Fees are charged as required.

Elements of a stock price

Because stock is existing photography and since you, not a client, may have shouldered the costs of production, the elements that make up the bottom line price for a stock photograph differ from those related to assignments:

Reproduction or Use Fee: the licensing fee based upon

- the usage rights needed,

- the costs to produce the image,

- and additional value factors (see box, "Pricing Factors")
 of a particular photograph and the client's requests.

Research Fees: are charged to compensate for a portion of the cost of selection and refiling of submission requests. They help to discourage casual requests by buyers who are not really serious or are only shopping for ideas or inspiration.

Holding Fee: a compensation to you for keeping the photos out of circulation and therefore from possible sale to others.

Loss or Damage Fees: are levied for any damage to any image(s) (transparencies, mounts, negatives, or prints)to compensate for lost potential future income from which a photographer is deprived because of the incurred loss or damage.

What Do I Charge?

Understanding the full process of pricing is akin to learning to drive a manual shift car. Once you know how, it's hard to remember what made it tricky, and it's even harder to explain the process in words. Photographers skilled at pricing have picked up their understanding through years of experience, absorbing it as they went.

The box "Pricing Factors" gives an overview of the relationship of the many factors that affect pricing. The better you understand them,the easier it will be to negotiate prices like those listed in the charts.

What about my photography?

Determining "do my photographs have value?" and "what is the value of my photography?" is not a lot less difficult than the age-old question,"which comes first, the chicken or the egg?" It's a dilemma that puzzles many photographers as they wrestle with pricing as a balance of their time, creativity, and the client's usage. Each question raises more questions.

What is my photography worth?

- Is it the value of my time?

- Is it the value of my creativity?

- Is it the value of my technical skill?

- Is it the value of the effort or risk involved?

- Is it the value of my photography vis a vis the
 client's project?

They all are part of the equation. But, which one is worth most?

Assignment pricing basics—the salad test

For the purpose of untangling the perplexities of pricing, let's say that photography is analogous to a restaurant meal and that the photographer is the restauranteur. The meal, or any one of its

15

courses, from appetizer to dessert, will vary in the quality of the ingredients, skill in preparation, exquisiteness of flavor, and elegance of presentation, as the graciousness of the service and the atmosphere will vary from restaurant to restaurant. Prices for meals in individual restaurants will vary according to the level of quality inherent in all of these aspects and the price to be charged will be based on the perceived value to the customer. Similarly, some clients require only basic meat-and-potatoes photography while others will be willing to pay more for the delicious flavor of your special lighting or elegantly decorated establishment.

That still leaves the problem of how to evaluate and price each element, whether food or photography. Which is worth more, and is it the same to all buyers? Naturally, it depends upon the buyers' needs and your costs.

Let's start with broad categories. The cost of a meal will depend on the category of the restaurant a patron chooses: deluxe, middle-of-the-road, or neighborhood bistro. Which one is selected will be based largely on the patron's ability to pay. These restaurants can roughly be compared to the budgets of advertising, corporate, or editorial assignments.

Now we'll narrow the analogy. Say the photograph itself is a salad. Imagine that all salads contain the basic ingredients of lettuce (your time), tomatoes (your skill), and a dressing (your creative ability). Special and more expensive salads may include endive or verdicchio or rare mushrooms; the list is practically endless.

Further, the waiter needs to know what size salad you need (analogous to client usage, for instance, it could be a major ad or perhaps an in-house newsletter): will it be an appetizer, a side dish or the main course? How important is the salad to your meal (is it for major advertising or a small brochure)? And finally, how many salads (the number of times they want to reproduce your photograph) will your party order?

It's that simple, and that complicated. However, if you don't make the effort to understand the elements of pricing, you'll be charging prices for lettuce no matter how many exotic ingredients you have lavished on your salad. A sure recipe for failure.

Calculating a Creative Fee

Determining your Creative Fee is a three step process. First, ascertain your Overhead, including a profit and salary for you, and then estimate the number of (a) days you can bill or (b) stock photos you can license for a year. Second, determine the basic amount, for the purposes of this book called the Minimum Daily Fee, that must be included in the Creative Fee to meet your overhead obligations (Note: this is **not** a day rate, but only an accounting for time.) Finally, once you know an assignment's specifications, factor in the specific variables we'll call Pricing Factors which include: time, usage, skill, creativity, special hazards, value to the client, and so forth, to arrive at your assignment's total Creative Fee. In other words:

1) Determine: (A) overhead (B) profit, (C) annual billable days.

2) Calculate your Minimum Daily Fee (Note: this is **not** a day rate).

3) Calculate your Creative Fee (Note: this also is **not** a day rate).

Because the variables called Pricing Factors are generally unquantifiable, it is difficult to place a dollar value on them. Experience will help, as will the use of the pricing charts later in this book.

How busy can you be?

How many billable assignment days a year can you expect? Fifty? One hundred fifty? Two hundred fifty? Let's find out.

A week has five work days for most people, so start with that. You should expect to work no more than fifty weeks a year, reserving two for vacation. Experienced photographers have shown that

• • • •

Pricing Factors

Three groups of factors affect pricing. The first two are determined by the client and/or the marketplace and the last by the photographer.

Market Type (Client/Market)
 Purpose of use:
 Advertising: selling a product or service
 Corporate: selling a corporate image
 Editorial: selling ideas or information
 Other: enhancing or decorating a product

 Photo fees traditionally relate to the budgets (media buy and total production costs) and profitability of the market area:
 Advertising: high
 Corporate: medium-high
 Editorial: lowest
 Other markets (like mugs or calendars): varies

Usage Needed (Client)
 Visibility factor: amount of visibility and length of time visible
 Size: e.g., 1/4, half, full page, double-spread
 Placement: e.g., interior, display, part opener, front or back cover

Number of uses:
 circulation: e.g., newspapers, magazines
 press run: e.g., brochures, books
 insertions: e.g., advertisements
Time: length of time used (e.g., one year billboard)
Distribution: where seen—local, regional, national
Versions: e.g., one language and two translations, or point of purchase and product packaging

Photographic Elements (Photographer)
 Everything that goes into a photograph:
 Time: e.g., photography, pre/post production, editing
 Skill: e.g., expertise, special equipment
 Creativity: e.g., imagination in color, lighting style
 Special: e.g., hazards, risks, unique contributions
 Expenses: all job costs—e.g., materials, equipment, assistants

All of these factors come into play when pricing either assignments or stock. The only real difference is who fronts the money for expenses. On an assignment, specific costs will be reimbursed to the photographer. Stock production expenses will usually be out-of-pocket (yours) and built into the fee later on, on a prorated basis.

for every billable day spent photographing frequently two nonbillable days are consumed—one for assignment preparation and the other for editing and shipping film, checking and cleaning equipment and many other assignment activities.

If you have one assignment each week (fifty per year), that's about one-hundred-fifty total days used up by those fifty assignments. You have only one hundred days left, two days a week, which will be just about enough time to do research to locate more clients,

have advertising and promotional pieces prepared, show your portfolio, buy and test new film, and do all of the other things a small photographer/businessperson has to do, like accounting, filing, promotion, answering the phone, and on, and on.

Again, experienced photographers have verified that a busy photographer can expect to photograph only one hundred days a year, especially if they have to travel. Studio photographers may have to seek more billable days because their overhead may be

larger. However, they probably have a small staff (and the accompanying costs) to assist them with routine proce-dures.

For our examples, which follow, assume we have two photographers:

#1, a moderately busy location photographer with 75 days of billable photography per year and,

#2, a busy studio photographer who has 143 billable days annually.

Determining overhead—how much are your personal needs?

Most people want to make money. Lots of money. But how much income do you really need on an annual basis? To start with, you have to figure a salary for yourself, otherwise why go into business? Too often, especially when starting up, photographers approach their small business without factoring in a salary for themselves, hoping instead to live off of any "extra profits." As a result they will never have a clear picture of the financial health of their operation, never will get ahead, and will slowly find they have to take more and more from their business, depleting its resources in order to ensure their own personal survival. For instance, a common scenario small business owners fall into is paying for personal travel on company money, instead of investing it back into the company. Not properly accounting for your own salary (or for every other cost) in overhead is a sure prescription for failure.

Learn early one of the cardinal rules of running a profitable business: Thou shalt not pull the wool over thine own eyes!

Determining income is somewhat simplified if you have recently been earning a regular salary; if your paycheck met all of your personal and family needs you know how much you have to make. If it wasn't enough, you need to make more. (And, if you were wallowing in excess money, why in the world are you reading this book?)

On the other hand, if you haven't received a regular paycheck you must formulate a budget showing what your housing, food, clothing, insurance, transportation, entertainment and all other personal or family needs cost you each year. The total is what you need for an annual salary. Remember though, if you are starting up a new business you'd better be able to sacrifice somewhat until you've become established.

What really is overhead?

Now that you know what you need in terms of salary it is time to calculate what it will cost to be in business for one year. Called overhead, these costs consist of both fixed and variable expenses.

Fixed costs are inevitable. Rent or studio/office ownership costs, for instance, are inescapable as are telephone bills and business insurance. Variable costs, on the other hand, will change in amount depending upon your activities, usually related to the amount of photography you do. But nonetheless, some variable costs will also be inevitable, even if you never have a billable day. For example, film will be used for testing, promotions, and/or stock production. It will vary week by week, month by month, but you will need to budget and account for it, as you will items like transportation, funding of retirement plans, and legal fees—all variables that can only be estimated.

Note: fixed and variable costs are not the same as those expenses billed to a client which occur only upon acceptance of an assignment. These costs, called Assignment Expenses, vary widely depending upon the nature of the job and are practically impossible to predict. Since assignment expenses are usually reimbursable they are usually billed to your client and therefore do not become part of your overhead commitment.

After you have listed all of your overhead costs, fixed and variable, add them up to derive your Overhead Total. Our examples for hypothetical photo businesses show:

Calculating Overhead

Fixed Costs Photographer	#1	#2
Depreciation:		
cameras, lighting, etc.	2,200	9,891
computers	940	2,366
office equipment	650	1,861
office furnishings	985	2,129
van/car/truck	2,450	6,667
Insurance	1,800	4,276
Rent	6,000	24,000
(or mortgage or % of home office)		
Salaries:		
yours	30,000	45,000
others	10,500	43,000
Taxes		
city	387	1,321
Federal	1,783	2,489
property	1,007	4,541
Utilities	2,400	9,322
(telephone, electric, gas)		
Fixed costs subtotal	**$60,102**	**$156,863**

Variable Costs Photographer	#1	#2
Production: film	799	4349
processing	1013	5492
model fees		8923
props		2,734
permits		500
assistants fees (freelance)		1,800
Professional Fees:		
legal, accounting		1,240
bank charges		98
Retirement		
(pension plan, Keogh, IRA)		8,450
Repairs: studio/office		1,400
photographic equipment	75	721
business equipment		373
Studio/Office: messengers		445
promotion/advertising	3,000	8,490
subscriptions/books		750
professional dues		275
education		
printing	2,000	3,215
postage	1,200	4,717
office supplies	1,000	2,786
Transportation: car	477	1,740
taxicab	123	429
other		313
Travel: hotel		2500
meals		876
air fare		3267
car rental		945
Variable subtotal	**$9,687**	**$66,828**
Overhead Total	**$69,789**	**$223,691**

Photographer #1- fixed costs subtotal $60,102, and variable costs subtotal $9,687, for an Overhead Total of $69,789 annually.

Photographer #2- fixed costs $156,863, variable costs $66,828 for an Overhead Total of $223,691.

Calculating for daily overhead

Take the Overhead Total and divide it by the number of annual billable assignment days you expect. The result is the minimum amount you must recover for every day you are actually photographing in order to cover (only) your overhead costs. Bill less than this and you'll soon be getting midnight phone calls from debt collectors. Confused? If so, return to "Calculating a Creative Fee" in this chapter.

Accounting for a profit

You next need to determine an amount that can be considered profit—after all, isn't the reward for being in business for oneself a profit? Simply put, profit is that money which allows your business to grow.

You could approach profit calculation from one of two ways: making it a fixed amount, or dealing with it as a percentage of overhead.

A fixed amount for profit could be any reasonable sum you wish, say $50 or $100 for every billable day, although it may have to be much more for a large studio operation.

Or, multiply the Overhead Total by some percentage to derive your Profit amount. Since many businesses find ten percent of overhead to be a more than adequate level, why not try that to start.

In our example for Photographer #1, the Overhead Total of $69,789, divided by the predicted 75 annual billable days results in a daily overhead of $930. Multiply the daily overhead by ten percent, which results in $93 per billable day for Profit.

Caution—this is not a time to indulge in fantasy. The Profit amount you use must maintain a reasonable relationship with your

experience and value to your clients. The important point is to understand the concept and importance of profit, and to always include it in your calculations.

Calculating the Minimum Daily Fee

Step one is accomplished. For photographer #1 we are estimating 75 billable days, Profit of $93 per billable day and an Overhead Total of $69,789. For photographer #2 assume 143 billable days, Profit of $150 per day and an Overhead Total of $223,691.

For step two, use the following equation to figure a Minimum Daily Fee. (Note: this is **not** a day rate, but the minimum amount you must recover every billable day)

Overhead Total	÷	Billable Days	+ Profit = Minimum Daily Fee

for Photographer #1

$69,789 ÷ 75 + $93 = $1023 Minimum Daily Fee

for Photographer #2

$223,691 ÷ 143 + $150 = $1714 Minimum Daily Fee

The Minimum Daily Fee (overhead and Profit) of $1023 is the minimum photographer #1 must include in "her" Creative Fee for each billable day of photography. Photographer #2, on the other hand, cannot afford to include any less than $1714.27 per billable day in "his" Creative Fee.

CAUTION!

We stress the importance of calculating overhead as a basis for establishing your Minimum Daily Fee primarily because most photographers ignore this basic business premise. You should also annually refigure it as a control on your business costs and as a guide for changing pricing.

Warning—this can be a trap! Although you need an understanding of your overhead, and should figure a Minimum Daily Fee, never forget that this is only a foundation. Be very careful that you don't let these numbers limit you in pricing. Remember, usage by the client and their budget remain the most important factors in determining price. One prominent photographer suggests keeping a sign by the phone "It's the usage, Dummy," to remind you to include all the relevant factors when calculating your price.

Calculating the Creative Fee

The third and final step in arriving at the Creative Fee is possibly the most difficult. Pricing Factors (see Box on page 17) will be added to the Minimum Daily Fee, resulting in the Creative Fee, the amount you will actually charge for an assignment.

The equation looks like:

Minimum Daily Fee + Pricing Factors = Creative Fee

The value you place on the Pricing Factors will be based on your level of experience and will affect your choice of the high-middle-low price range when you use the Price Charts. You will notice that the Pricing Factors chart is absent any financial figures. Because it is impossible to place a specific value on them, experi-ence will become your best guide. Until then, use the Price Charts later in this book to help you seek a range.

Value to client

As client need increases so, usually, will their willingness to pay. A perusal of the pricing charts, for instance, will show that advertising assignments, in general, will bring higher fees than will editorial. In part, this has come about because of the demands of advertising—bigger productions, more prominent display of the finished product, and, frankly, because you will be helping some company make more money. So too, within any one category you will also find varying rates. For example, corporate annual reports, because they help "sell" a company to investors, will usually support higher Creative Fees than will photographs destined for an in-house magazine.

One of the most important indicators of importance to a client is found in either the publication "space rate-media buy," in the case of advertising, or in the total production costs of corporate and editorial, and even advertising, projects.

The advertising agency has to place the advertisement where the public can see it, usually in publications. The costs of this space varies—the space rate for one page in *Time* magazine will cost much more than a local publication, likewise a billboard along a major city freeway will cost more than one in a small town. The easiest way to determine space rates is to look in the publication *Standard Rate & Data* (commonly called the *Red Book*) at your local library. It contains the advertising space rates for magazines published in the United States. While you can't be expected to know every rate, you should have an understanding of the relationship between space rates and the value of an assignment or stock photograph price.

In corporate photography, an estimate of the value of a project to your client can be made by knowing the project production costs total, and it can also be used as a guide for advertising and edito-

rial assignments. More difficult to determine because there is no easy guide book, you will have to know the final size of the piece, the press run size, and so forth. Talk to printers, talk to graphic designers, or guess. But do try. Sometimes your client will offer some or all of this information if you just inquire. Why not simply say: "This looks like a major effort, and I'd like to be part of it. You say the annual report is going to be sixty-four pages with a press run of one million! Who is going to be the lucky printer?"

Editorial photographers will probably not discover the production costs incurred by a publisher, but instead will have to rely more on the press run and/or circulation of the publication as a guide to the importance and value of the work. Publishers tend to work with set rates for photography so you may hear terms like "page rate" which simply means that they have budgeted a certain amount for photography per page. If it is by page rate, an indicator of project value would be any variance in the page rate from other projects this publisher has produced. Remember to check the *Red Book* for the space rate of a publication you are thinking of work for. Higher rates denote a higher value is placed on each page by the publisher and it may mean higher fees for you; but only if you ask.

Value to you

Although it wouldn't be advisable to routinely factor this into your pricing and negotiating routine, some photographers give consideration to whether an assignment's photographs will be desirable as stock. If a job promises great photographic possibilities some photographers may consider a slight downward pricing adjustment to ensure capturing the assignment. They are willing to risk the reduction in income knowing that future stock sales will offset the lower assignment fees.

Warning! This should only be considered by experienced photographers with established stock sales records who can accurately assess the outcome.

Don't give your work away. No one will really appreciate it and you can't operate a business for very long on hope—hope in the form of future stock sales.

Pricing The Assignment

Using our hypothetical photographer #1, assume that the assignment is for an ad in a trade magazine, with a rather small circulation—about 25,000. The ad will run one year, will be a full page, be inside the magazine, and not be a cover. The time required to do the actual photography will be one day, with a full day for pre-production, including briefly interviewing three models the photographer has already worked with. In other words, this isn't a terribly complicated assignment, but will require some special skills (multiple exposures) in the camera.

Accordingly, the photographer factors in additional compensation because the photo is destined for an ad and for her ability to do the multiple exposures and required special lighting. She checks the *Red Book* and sees that the page rate is fairly low, but consistent with other magazines of that size. She decides a Creative Fee of $2,500 should do since the magazine has a relatively small circulation and only limited usage is requested. Note that the Creative Fee is above her Minimum Daily Fee of $1,023 (recovery for overhead and profit) because it includes the factors of the media buy, her experience and lighting skills; plus other Pricing Factors that she determined apply in calculating this assignment's value. Photographer #2 would follow the same process factoring in studio costs.

Stock Photography Pricing Basics—How Many Stock Photographs can You License?

In the case of stock photography reproduction licensing you are faced with the problem of determining quantity, not of billable days, but of how many images you can license for use on an annual basis.

There is always the temptation to lower usage fees in order to

stimulate additional activity, but this is usually a vain effort. More often than not, the major stimulus to completing a usage agreement isn't price but image quality, appropriateness, and project importance to the client.

Determining the daily cost of being in business

We have to look at stock pricing somewhat differently than we did assignment pricing. First, you need to determine what it costs to be in business each work day of the week (not per billable day). The following hypothetical case assumes your business will be one-hundred percent stock photography. If you do a combination of assignments and stock you'll vary the approach.

$$\text{Overhead Total } + \text{ Profit } \div \frac{\text{Work Days}}{\text{Per Year}} = \frac{\text{(Work) Day}}{\text{Minimum}}$$

Overhead total

In this case, assume another photographer, #3, whose business is practically identical to photographer #1. However, #3's overhead also includes (in addition to the same overhead as #1): an additional $9,000 in film and processing, model fees of $3,000, $1,500 in props, and $450 in permits. #3 also shows additional overhead of $1,200 for car, $425 for cabs, and $230 for other forms of transportation. All of these additional overhead expenditures reflect the difference in operation between #3's stock photography business, and the straight assignment business of #1. The total for #1 was $69,789 but for #3 it is $85,594.

Photographer #3 takes that total and divides it by 250 work days (50 working weeks per year, 5 days per week). The result, $342.38, is the cost of being in business each business day. In other words, if you are like photographer #3, your business will hemorrhage at the rate of $342.38 per work week day, whether you ever license a photograph for use or not!

Like most businesses, some days will see higher receipts than this, some will be lower, but in the final analysis you need to bring in at least this much on an average daily basis. Keep this number visible, perhaps tape it on the wall near the telephone, to remind you that you are in business and can't afford to give anything away!

Pricing the stock licensing agreement

Next, add 10% for profit; if this photographer is pursuing only stock photography, and is going to remain in business, the equivalent of $376.61 must be brought in each and every business day. Or, at the end of the week, the books must show total sales of $1,883.

If you are beginning a business, just like "guesstimating" the number of assignment billable days you can attract, it is often difficult to determine accurately just how many individual stock licensing agreements you can complete. Therefore, for Profit, take a percentage of your annual income you estimate will come from all stock sales. Let's say it will be ten percent and your overhead is $94,153. That being the case $9,415.30 (ten percent of $94,153) must be added to your Overhead Total to include profit. The total is $103,568. You now know you must recover $103,568 this year, whether it is through one stock sale for $103,568, ten sales of $10,357 each or one-hundred sales for $1,036 each.

In stock, as in assignments, what you need to cover your overhead costs is only one factor in pricing. Your price must also reflect the value of the usage to the client—remember the media buy production cost relationship. (see box "Pricing Factors)

By cross checking with the pricing charts you will be better able to estimate "going rates" for stock. This should help you analyze how much to charge per "sale." Note, however, no one can tell

The Future is Here

You should already know, and will be hearing a lot about digital photography, digital imaging, CD-ROM, electronics, computers, modems....

The taking of a photograph with an electronic camera or the ability to manipulate a photograph with a computer or the possibility of sending hundreds of images to a client via a telephone line are already realities and will soon be everyday tools. Most photographers, to remain competitive, will have to become conversant with the new terminologies and technology.

• Digital photography is the taking of photographs with a camera which stores the image(s) as electronic data instead of using film.

• Digital (or electronic or computer) imaging is the storage of photographs as electronic data so that it can be used, manipulated, or transmitted via computers.

• CD-ROMs are but a means of storage, much like traditional computer floppy disks, except that they hold quantum amounts more data or, in this case, photographs. In the future, whether or not it includes CD-ROMs, we will certainly see art work and books of all kinds appearing on electronic media, as opposed to paper.

(Note: in this book we will use digital imaging as something of a catch-all phrase to include any type of electronic photography.)

For photographers, this is a period of wonderment, as we watch companies parade new goodies before us, hoping we will buy them. Our photography portfolios will soon be distributed on disks. "Books" will be produced without the difficulties of printing and the destruction of natural resources.

Now is a time for experimentation, learning, and, yes, even caution. As photographers discover new methods to expand their artistic vision and new markets to distribute their work, they also will be tempted to lose sight of their primary business goal: making money.

Where will the money come from for all of the expensive equipment that digital imaging requires? Or, will your clients even be willing to accept your work on a SyQuest (a portable disk drive cartridge used for storage and transport) instead of film?

Even during this infancy of digital imaging there are already people trying to convince photographers to give up their valuable images for a pittance so that they can introduce new products based on CD-ROMs. Their explanation for not wanting to pay, or pay much, is "...this new market is experimental." And some photographers will find that unscrupulous clients and color separators will scan the work, keeping images on file electronically to be used later, or sold to others, without the photographer's permission. And, some work will be "lifted," to be used in other projects without payment to you. Electronics simply makes it easier to be a pirate.

You needn't fear the future, but neither should you close your eyes to it. If you don't take some simple steps now, protecting yourself and your work, you could find the future to be something less than the exciting promise it holds. Terms and conditions on your paperwork restricting usage will help, as will making sure that the people you are dealing with are honest and that the contracts they offer you are in your best interest and not just theirs.

What else can you do? Contact ASMP, The American Society of Media Photographers (see Bibliography), about what steps they are recommending photographers take. They regularly publish information about industry trends and news that will allow you to know what other photographers are doing, both to promote and protect themselves. But most important of all—you must realize

that your work has value, to you and to others. You can't afford to give or let it slip away.

Because there are so few photographers currently working in the area of digital imaging it is too early to know how the pricing of this type of work will evolve. It takes a long time to produce the work—probably longer than most clients will be willing to pay for, the equipment or equipment rental time is very expensive, and if you own the equipment it may be obsolete within two years. However, at this time some photographers who are working with computer manipulated images state that they can easily get twice their normal rate for doing digital imaging and three or four times their normal rate is not impossible. While this amount of money may seem enticing, these photographers also concede that they have to spend three to four times as much time working on a project. If, however, they are doing only a few, simple, rather mechanical things they say they may charge their normal price plus an additional amount for digital, plus any expenses incurred. Since service bureaus charge $75/hour to and beyond $350/hour why not charge something in that area for average digital work.

One photographer said that his approach to pricing this type of work was more like that of an illustrator than a photographer. For the price, he expected to have to produce three versions: a rough for initial changes, a semi-final which incorporates the changes, and one final version that includes small changes from the previous semi-final rendering.

It is felt clearly that charging on a time basis alone is unwise, just as it is for "pure" photography. Time can't be ignored, it is one of the elements of pricing, but the same factors that affect photography pricing also must influence how you price digital imaging.

Perhaps most importantly, because the new technologies are placing intense demands on photographers, many will be tempted to underprice their digital work, hoping it will entice clients. The authors have actually heard reports of photographers offering to do digital manipulations without charge for this new technology in order to influence a negotiation. Having made the extraordinary investment in computer digitizing equipment, some photographers almost seem thrown into a panic, and, wanting to show their new capabilities, offer to toss it in for free.

Possibly these photographers misunderstand that it's sensible business to charge for access to the equipment and the expertise that goes with it. Buying thousands of dollars of digital equipment is not equal to buying a new lens. It's not merely another aspect of having the right tools to do a photographic assignment. Digital imaging is a distinct additional service. Giving away digital services is virtually analogous to a photographer hiring and absorbing the expense of the retoucher the client chooses to use.

A slight discount for first-time users would be a more appropriate marketing technique.

Currently, many service bureaus (companies which offer computer desktop publishing services) charge $85-$125 hourly for routine digital imaging work. If they charge for it, so can you.

If photographers give this work away now, their clients will expect it in the future. After all, how can you later charge for something you once gave away for free? Photographers who undervalue or give away digital work for free will have destroyed a potential profit center for themselves and will have lost an opportunity to protect their images. If your images leave your hands, and end up in the computer banks of other people, who's to monitor their future usage?

As is common with issues like this, you, and your fellow photographers, hold the key.

you how many sales you can expect, only what price you will need to charge in order to fulfill your income goals.

A Mix of Stock and Assignments

Our examples assume either a pure assignment or stock business. In today's market few photographers find that they are either one or the other, most finding a blend of the two to be more rewarding. It will be up to you to decide artistically if a blend will work, as it will be to determine how you will blend the two financially.

How Successful Do You Want To Be?

This chapter has taken you to the first step: showing how to calculate what you need and how to figure how much you must charge so that you can fulfill those needs. It has also provided you with, in effect, a way to provide a safety net. Do not, however, confine or limit yourself to merely covering your basic needs.

Your next step is to learn to negotiate beyond need to what you deserve— to prosperity. Your success will depend upon what you can command (your abilities), your preparation (knowing what you need and how to achieve it),and your desire.

Valuation—What is a Lost or Damaged Photograph Worth?

The loss of an original transparency or negative is a serious, sometimes devastating, occurrence. Your photographs have value as income producers for years to come—they are a part of your life work, an annuity for your heirs.

All professional photographers should be knowledgeable in this area. For detailed coverage, read the books on stock and legal practices cited in the Bibliography, particularly ASMP's booklet *Valuation of Transparencies* by ASMP Legal Counsel, Michael D. Remer.

Here's a brief summary:

- It is standard practice in the industry to charge for the loss or damage of a professional quality, professionally edited original.

- Your earning power is diminished by each lost original.

- The amount of the fee that will be charged for loss or damage can (and should) be stipulated in your paperwork. This shows you have thought about the specific value and are alerting the user so they can protect the materials in their care.

- The commonly used figure of $1,500 originated in the early 1970's and has been upheld in many court cases. Because of inflationary factors, many stock agencies are stipulating $2,000 for the work they represent.

- Whatever amount is stipulated, whether $1,500 or any other amount, it must be demonstrable should there be a conflict and you end up in court. Merely stating the value doesn't guarantee it. It helps if you have confronted the issue in your paperwork by stipulating a figure, but the court will decide if there is a reasonable relationship between your stipulated figure and the photograph's actual value. They must determine that the figure isn't punitive and that there is a basis for the valuation level.

Among the factors that have been cited by the courts in determining value are:

Technical excellence
Selective eye of the photographer
Prestige and earning level
Uniqueness of the subject matter
Established sales or use prices
Group value of the individual slides
Frequency of acceptance by users

Chapter 3

Negotiating Principles

egotiation is an art. It is also an essential skill in business. Any photography business, whether assignment or stock, will founder without a good flow of income derived from the successful negotiating of prices.

The keys to a flourishing photography business are good photography, knowing what price to charge, and being able to negotiate to get that price.

The prices listed in this book are helpful. They show the range of fees being charged by your colleagues throughout the industry, but they are merely a starting point. Without strong negotiating skills, the prices in this book will be of limited help.

Picking a figure out of a price-list may seem the easy answer to a client's request for a price quote. But a price-list price can't possibly offset the intimidation you'll feel from a client who pretends to faint or who barks "You're charging what?", if you haven't truly and fully understood why you selected that price.

At that moment, your adrenalin starts flowing and fear takes over. Without the information to back it up, your price, if plucked from a list, becomes a straw in the wind. Only a firm grasp of the economics of your own business (including your bottom line as outlined in chapter 2), and skill in using negotiating techniques will make you comfortable answering that client's confrontational question calmly and from a position of strength.

Strength comes from understanding and believing that the figure you've quoted is a reasonable one. It comes from being able to articulate why you quoted that price, and from knowing your bottom line.

The first step in building that negotiating strength is to break the chains of stereotypical attitudes.

Attitudes Toward Negotiation

Negotiating may be photographers' least favorite aspect of the business, and their single greatest weakness. Often, we are our own worst enemies when it comes to dealing with money. A combination of myth and misconception intrudes on our ability to require a fair price for our work.

A fortunate few are born with a natural skill at negotiating. They like the challenge and the excitement that comes with making a successful deal. As surprising as it may seem, negotiation is second nature to them.

But the majority of us must learn how to negotiate. With time and training anyone can become an effective negotiator. It's done by practicing technique and by summoning courage.

The first step is to throw off the yoke of misconception which holds us back from acting in our own best interest. Some of us work with the naive belief that our talent will be recognized automatically and justly rewarded. Also, we may buy into the following myths:

27

- It is undignified for a creative person to talk about money,

- You may appear pushy, materialistic, or greedy by holding out for a fair price,

- Our worth is measured by the amount the client is willing to offer (they must know how much we're worth), and

- If we don't accept this deal the buyer will never call again.

Fear is the culprit here. Fear of what a client might think of you. Fear of taking risks. Fear which paralyzes. The effects of fear are far reaching. They get in the way of clarity, preventing you from asking the right questions and getting the information you need to quote an accurate price.

Where did these attitudes originate?

It has not been routine in our culture to negotiate prices for consumer goods. Historically, we have been more likely to accept and pay a ticket price than to assume we should bargain. In addition, a few arrogant or unpleasant photographers have made negotiating a dirty word. But there are many fainthearted photographers who by their lack of courage have done equal damage to the climate for negotiating. They mislead buyers into believing they can dictate photography fees, sometimes to a level below what it costs to run a business. These photographers have accepted the underlying message that we can't sell our work if we dare to question what buyers offer.

Successful, amicable negotiations occur every day in the photography business. To learn the tactics to emulate these transactions, we must first shed old habits.

Changing attitudes

To change the attitude, face the attitude. A first step in taking the risks necessary to becoming a good negotiator is to change the way we view the world of negotiating. Consider that reality is the opposite of the myths listed above.

Consider that:

- It is fair and reasonable to charge enough to earn a living,

- It's possible to explain why you must charge a certain price in a dignified, professional manner,

- Charging a fair price is a way of showing respect for your photography,

- Self-confidence is not incompatible with creativity,

- It is not reasonable for a buyer to expect to use photographs for whatever price they want to pay, no matter how low,

- You are not personally responsible for the survival of the client's project,

- A love of photography doesn't require us to subsidize everyone who asks,

- It is possible to say "no" courteously to a buyer and have them call you again.

If you are still having trouble justifying your right to a fair price, consider an enlightened self-interest approach. Getting a good fee allows you to improve your service to the client. It allows you to invest in new equipment, spend time and money on testing film, filters, or lighting, and to experiment with new creative approaches. Explain to your client why you need to maintain a fee structure that allows for investment in research and development and how it benefits them. But, make sure **you** believe it first.

In order to feel comfortable making your negotiating points to a buyer, some photographers role-play a buyer/seller situation with each other. It is a technique used by some stock agencies to train

their new sales people. The "buyer" writes down a type of photographic usage, the top price the client's company is willing to pay, and the low price that is their goal. The "photographer" writes down the lowest acceptable price as well as the highest price that seems even remotely possible for the usage—the dream fee.

They begin discussions. When an agreement is reached, the winner is the one who came closest to their goal price. It is a great technique for polishing the rough edges of negotiating and it is fun.

Be vigilant when negotiating because, given half a chance photographers sell themselves short—needlessly. With clients, your tone should be pleasant and accommodating, holding absolutely firm when they can't meet your bottom price, but all in a cordial manner.

The reasons? It's a better negotiating tactic to be pleasant. But the more important reason is that this is your world, this is how you spend your days, these are your clients. They sometimes become friends. Why not make the time and process enjoyable. Being contentious won't add any joy to the day, sell any more photographs, or land any more assignments.

Negotiating Strategies

Becoming a good negotiator takes practice, a knowledge of the business (so you can educate clients), and confidence in yourself. Lack of courage is what limits most photographers.

The goal and measure of a successful negotiation is clarity, a fair price, and a return client. You need clarity to avoid the confusion and misunderstanding that breeds conflict, a fair price so you can stay in business, and a repeat client because that's how you continue to prosper. The ideal is that both you and your client are happy with the outcome of a negotiation.

You may say, "What's to negotiate? The buyer has a price and a budget in mind, that's what they'll pay, and I can simply take it or leave it." Wrong. Every time you discuss price or assignment

specifications it is a negotiation. The only question is how successful the outcome is for you.

There are six basic steps that take place in every negotiation, whether handled in ten minutes or over a period of days, and they are crucial to the process.

Negotiating Steps

Establishing rapport is the first step in any contact with a client. It may seem self-evident, but start with a friendly, welcoming tone. Find some common ground—the weather, the holidays, recent events. Next, express your interest in their project. You may think it's obvious that you are pleased by their call. Not so. Say it. Show interest in their company, their publication, and this particular request.

If you set a good tone they will enjoy the exchange and remember that it is pleasant to work with you. Removing a little stress from their day will stand you in good stead.

Learn to read the mood of the client through voice inflection or body language. When a client is busy and not inclined to small talk, pick up the clue. Stay cordial, but conclude in a quick, professional manner. However, don't let them rush you into a price quotation before you get the facts. It's perfectly legitimate, and to their benefit, to ask for time to give thoughtful attention to figuring a price.

Gathering information is the critical step. Ask about usage. You must know where, how big, for how long, how many times, and for what purpose the picture will be used. Make clear that you can't quote without this information, and explain why. Let them know that price depends on usage, size, and many other factors. Make the point that by being very specific with usage you may be able to give them a better price.

When quoting an assignment, explain that it's not only usage that affects the fee but the complexity of the shoot and pre- and post-production logistics as well.

In stock, the fee can also depend on which of your photographs they are considering—one produced under normal conditions or one involving high model costs, travel expenses, or other costs which will affect the price.

Use the telephone information forms in Chapters 4 and 5 to make sure you've asked all the pertinent questions.

Educate the client. When you are dealing with a knowledgeable long-time client or a new one who clearly knows the ropes, you may not have to do any educating. But if you suspect that the buyer is new to the field or inexperienced in the area you're discussing, then it will help if you clarify industry standards for them as the groundwork to negotiating.

One sign of inexperience (or an experienced but tough negotiator) may be a reluctance or inability to give you information about their project, particularly about usage. "Just tell me how much, I'm not sure how we'll use it" is a giveaway. It's more likely to stem from inexperience than duplicity, but it still creates an impossible negotiating atmosphere, for you at least.

Explain that it is industry standard to price by usage as well as your cost to produce. Let them know that it works to their advantage to limit the rights they need. Explain that vague, sweeping, all-encompassing usage can be very costly. Help them create a range of fees if they aren't sure about future uses. Indicate that potential future rights, negotiated now, will be lower than if they come back to you in a few years. Say something like: "We could create a package deal for you with any future uses for posters rated at $xxx and brochures at $yyy." This approach relates to assignment usage rights as well as to stock fees.

It is vital that you focus everyone's attention on the disparity between the enormous cost of media placement and the cost of photography. Doing so reminds your client of an obvious fact they may wish to ignore and it helps reduce any insecurities you may feel about asking for a fair deal. After all, it's the image-maker that provides the emotional resonance of the advertiser's message; and you deserve a fair share for that contribution.

When negotiating assignments, pay very special attention to any request for work for hire, all rights or buyouts from any client. Use the reasons listed above for limiting rights needed. It's enough to say here that buyouts should be avoided like the plague since when you give away all rights you are dramatically limiting your future earnings by killing off residual usage from the assignment client and any stock use whatsoever.

Here's another red flag that may indicate inexperience in assigning photography: "We need the Pittsfield facility photographed and it's a one-day job. No, the Corporate Communications VP will be out of town. No, we don't have the plant manager's phone. He'll show you around when you get there." Let them know why vague, free-floating arrangements can cause expensive assignment problems, and, that part of helping them get the best price is to avoid disasters in the making.

When informing an inexperienced client, handle it in a subtle, friendly manner. List the factors that affect a stock price or assignment fee.

In order not to appear condescending or didactic, use the phrase "As I'm sure you understand..." to preface your comments. You are presenting information in a way that helps the inexperienced client relax and possibly save face, so that they can hear your information in a neutral environment.

But, why are you dealing with inexperienced people? In today's tight economy, many advertising agencies, corporate communica-

• • • •

tions departments, and editorial art departments have eliminated various levels of support positions. An overworked art director or photo editor may even use a trainee or secretarial assistant to do their ground work. You are helping yourself when you help the caller become informed.

Don't hesitate to offer books and other sources of information to give objective backup to your position by referring an inexperienced client to this and other books. (It might be wise to do this BEFORE pricing comes up if you can.) "If you don't have copies, You might find some of the ASMP publications useful. They provide a good background on what we're discussing..."

Understanding on both sides makes the process work.

Quoting the price. Though basic approaches still apply, the actual discussion of numbers is where stock and assignment price negotiations will differ.

When negotiating stock prices you are usually discussing a specific picture. The buyer will use the photograph, or not, based on how closely the perceived value to them matches the reproduction fee you quote.

However, assignment pricing is complicated by many factors, including costs of pre-production planning, props, models, crew, rental fees, location fees, travel time, creative fee, and photography expenses, such as film and processing.

In pricing either area of the business, stick with the principles:

- get the information,
- don't be rushed into a quote,
- quote a range (to leave some leeway for movement)
- have a bottom line.

The following chapters will go into specific detail on pricing considerations for assignment and stock.

You must guard against taking the short-sighted attitude "Good for me if I can just cover my overhead, plus a little extra, and save the client. Why not?" This viewpoint continues to cost photographers, from the amount of money they can put in their pocket to the amount of money they will be able to make in the future. Why? Clients use previous production budgets to calculate current and future budgets. Many art buyers have said that once the account executives and clients have gotten accustomed to getting good, usable photography at the fire-sale prices that have prevailed for the past few years, it's almost impossible to increase budgets for future productions. So whether it makes sense or not, the art directors are given smaller and smaller budgets to work with and told to "Make it happen! Find a photographer to do it for less." And the downward spiral continues. As long as there's no resistance from photographers, pragmatic buyers will continue to squeeze more from the overall budget (at your expense) to cover the ever-increasing cost of media space.

Closing the deal is an aspect of negotiating that some photographers let slide. It can cause messy repercussions through misunderstanding. Once you have negotiated a fee, make sure it is clearly understood by both parties. For a stock usage, ask the buyer if they will be sending a purchase order. Assignments often include complex and detailed estimates as a part of the negotiating process. In addition to asking the client for a sign-off on your final estimate and a purchase order, send your own follow-up memo confirming specific aspects of the assignment, such as who handles what: researching locations, booking models, making travel arrangements, and so forth.

Note that the exact license of usage rights must be spelled out in your invoice both for stock and assignments. At this stage you are merely summarizing what you will be billing for later.

Follow up. Letting a client know that you are interested in the outcome of an assignment or the results of a major stock usage is important. On an assignment, call shortly after the finished work has been received to see if they are as pleased as you were with the photographs. Check in again later, once the materials are printed. Use that as an opportunity to request tearsheets. Ask about the success of the project, learn how others in the corporation viewed the work, and possibly find out about future plans.

Following up is a way of letting the client know that you value the relationship with them, that you are serious about your work, and that their success is important to your satisfaction with the job; you don't just take the money and run.

Value of Photographs

Photographs have value to users only to the degree that they solve a visual problem for them, whether it's illustrating a magazine article or advertising a product. The amount they will pay to assign a shoot or to reproduce a stock photograph depends on what they perceive as the value of that particular photograph to their project.

The value of a stock photograph or assignment, to you, is much more complex. There are economic, aesthetic, and emotional components that sometimes cloud the pricing issue. Photographers may hesitate to charge enough for a stock photograph they especially like, not wanting to risk having their price turned down.

Assignment photographers may be tempted by the opportunity to shoot in an exotic location and may dramatically lower their fee in the mistaken belief that they shouldn't be well paid for something they love to do or that the only way to secure the job is to charge little.

Take a cool-headed look at the economic value of your photography.

When quoting an assignment, understand that any special

equipment, techniques, or skills you have to offer add value that affects the fee. You are charging for your creative and technical abilities, not just your time.

In stock, you can and should place greater value on some photographs than on others. Measure your photographs and price them based on their cost to produce and on their unique quality, not only on the client's intended use or ability to pay. (See chapter 5 for a list of those factors that affect pricing of stock.)

Negotiating Conversations

Having absorbed these principles of negotiation, you must now believe; believe that you have the right and the ability to negotiate a fair price. Once you are a believer it's simply a matter of expressing these negotiating methods in your own style. There are many rhetorical devices that can be used in a negotiating conversation as you'll see in chapters 4 and 5. No matter what words you choose, remember to communicate the following:

- You want to help the client, to work it out, to conclude a deal,

- You understand their problems,

- You hope they understand your situation,

- You are disappointed when you can't reach an agreement

- You hope that there will be another opportunity to help them out.

Your tone is accommodating. A polite but firm manner must be shown when you have reached your bottom price. Regardless of how you really feel about the negotiation, you must project an earnest desire to solve their problem. In fact, you **do** want to conclude a deal, and you are disappointed when you can't answer their needs. Not only is an accommodating attitude smart negotiating but it usually has the additional merit of being true.

Negotiating in Hard Times

Price cutting is not the answer to a tight economy. It's easy to say, because it's true, that to get work in a tough climate you must be better, more original, and more creative than the next photographer. It certainly helps. However, in assignment work personal attributes are valuable to a client as well. Being perceived as someone who is easy to work with will give you an edge, perhaps even over a very creative, but arrogant, hot shot. Competence and dependability are highly valued, especially when money is in short supply. Make sure you let clients know your ability to meet deadlines and solve problems. Buyers may be less likely to take risks during hard times so promote your dependability, along with your creativity quotient.

Finally, remember that negotiation is not at odds with the creative aspects of photography. Believe it or not, there are many photographers who are good photographers, skilled negotiators, and nice people.

Steps in Negotiation

Establishing rapport: create a friendly climate for doing business. Open or respond in a pleasant manner. Express interest in their project. Set the tone as professional and cordial.

Gathering information: whether you are negotiating an assignment or a stock reproduction fee, it is critical to get enough information before beginning a pricing discussion. Find out the usage: for what purpose, where, how big, for how long, how many times, and so on.

Educating the client: this may be necessary when you suspect that the buyer is new to the field. Before quoting a price make sure that they're aware of industry standards. In a concise, polite way, set out the factors that affect a stock price or assignment fee.

Quoting the price: do not talk money until you have all the information available about usage and production requirements. Do not be rushed. Assignment estimates can be complicated—you need time to give a responsible quote. If possible, find out their budget before you answer the query "what do you charge?" Quote a price range to encourage their response. Know your bottom line, the figure below which it's not worth making a deal.

Closing the deal: when you have agreed upon a fee, expenses, and a production budget, make sure everything you have negotiated is clearly understood. Request a purchase order. Confirm in writing, by fax if necessary, by sending your own estimate form and a memo confirming your understanding of all the details of an assignment.

Following up: checking in with a client, particularly after you've turned in an assignment, is a useful way to let them know that you value the relationship and are serious about your work. You can request tearsheets, ask about the success of the project, learn how others in the corporation viewed the work and find out about future plans.

Chapter 4

Negotiating Assignment Photography

W hen you determined your Minimum Daily Fee it was done with some precision through mathematical analysis; negotiation is less scientific. However, the successful blending of the two, pricing and negotiating, will largely determine your future financial success.

"Hello, this is Susan, art buyer with High Tech Advertising. We really liked seeing your portfolio the other day. We have a client that needs photography for an annual report, and we'll possibly use some in trade advertising. Can you be in Seattle on the ninth to photograph an ABC Company executive and Chicago on the tenth to photograph a special manufacturing process that only their XYZ Division does? Sarah Q. will help you out in Seattle and Joe B. in Chicago. Let's see, that ought to do it. What'll it cost?"

Flattered, thrilled, you doodle on a pad of paper hoping desperately to be able to arrive at a price while Susan waits on the other end of the phone. Stop! Hold it! Don't throw everything you've learned out the window now. At this stage of the negotiation you need

to review the six Steps in Negotiation mentioned in chapter 3, and apply them to an assignment. To repeat (once more) those stages are:

1) Establishing rapport,

2) Gathering information,

3) Educating the client,

4) Quoting the price,

5) Closing the deal and,

6) Following up.

It's important to understand how to apply negotiating principles. Negotiating the price for an assignment differs from negotiating a stock price in several ways, as you'll see in the following chapters. A stock photograph is already in existence. The major factors influencing its pricing will be usage and the unique qualities that give it additional value.

However, an assignment photo is still on the drawing board and exists only as an idea in the mind of the client. In addition to the factors of client usage, assignment pricing takes on the complexity of many variables such as weather, transportation, location scouting, set construction, casting models, and locating props, to name just a few, all of which involve logistical coordination and must be estimated and scheduled into the time available for the shoot.

The unwary photographer may end up volunteering days of time: serving without fee, for instance, as a travel agent, casting director, or corporate coordinator for a client. Also, the inexperienced photographer may forget the axiom that the less time you have (for pre-production) the more it will cost (to make the deadline). Rush charges exist in every area of business whether typesetting, printing, binding, or prop acquisition. If you are not precise and thorough in your pricing estimate you can estimate yourself right out of business.

Controlling the Negotiation

Knowing and asking the right questions, not allowing yourself to be intimidated, learning to control time, and being sensitive to subtle signals will allow you to begin to control, and not be a victim of, the negotiating process.

Get all of the assignment information you need. Exactly who or what are you to photograph? What's the time schedule? Who is to meet you? When? Where? Who will make the travel arrangements? Who are the photographs for—the ABC or XYZ annual report? Cover? Inside? Major display or just insert photos? Will they actually be used in advertising or is this just speculation?

Don't assume anything, and don't leave anything to chance.

Be wary of clients who won't allow you reasonable time. Sometimes they just don't have much time, but most often they are trying to control you, even if they don't realize it. Buyer: "Because the assignment is tomorrow morning I'm pretty jammed up. The photography shouldn't take long... We just need a few shots?" Look out! They are pressuring you into a fast answer because of the impending deadline, and implying that the job has little value due to needing only "a few shots."

If you aren't scared off by now, you immediately need to begin asking some probing questions: not only will you help protect yourself but a subtle message will be sent that you are a professional, and a professional job is much more than a "few snaps."

Establishing Rapport

Do you want an edge in your negotiations? Although you may not think so, your client may also be uncomfortable discussing money and bargaining with you. You can help yourself immeasurably and improve the negotiations by establishing a genuine sense of rapport. A positive outlook about the job, about your business, about life in general will help instill confidence in you.

The Japanese are effective negotiators partly because they spend what, to us, seems to be an inordinate amount of time getting to know all of the parties in a negotiation. They are very aware that it becomes more difficult to say "no" to someone you are friends with.

Sometimes the sense of rapport can be a major element in the decision about which photographer to use. One woman was chosen over several others, all equally qualified for a plum assignment. After talking to each, the publisher felt that, due to the many days of the overseas assignment, they could travel and work better with her than the other photographers they were considering. Also, some of the others had shown a little testiness during the negotiating process. Take note!

Gathering Information

As we must repeat and repeat, in order to accurately price an assignment you will need to gather complete information. Obviously some negotiator/photo buyers will be willing to discuss these things openly with you. Many, however, will try to guard the information as a bargaining ploy or will simply not realize the importance of it to you. Don't forget to say "So that I can keep my estimate as accurate and as reasonable for you as possible I need to know ..."

It is too easy, and the stakes too high, either to forget or to neglect to ask something about the assignment you are quoting on. Use the Telephone Information Form in this chapter to assist you.

Ascertain: how the photographs will be used, where they will appear, the size and for how long. Determine the media buy or the production budget for the job, either of which should give you some idea of the value of this job to the client. It's easily done by asking, "So that I can quote you a more accurate price, tell me, in what magazines will this ad appear?"

You need to know exactly where you are to be, when and who to meet, and what you are going to photograph. Also ask if there are

any potential problems you should be aware of. Some years ago a photographer traveled with five steamer trunks of lighting equipment and numerous assistants for a major assignment at a brewery. No one had volunteered the information that the brewery workers were on the verge of a strike and tensions were extremely high. Workers refused to be in the photographs and the assignment was delayed for a day while middle management people were brought in from another plant. You can't anticipate everything, but a few questions might have elicited the information to sound a warning; "Who will our models be? Are they employees? Has it been cleared with them?"

Some extra thought in posing the right questions can go a long way toward making your pricing efforts, and subsequent assignment, run smoother.

Bid or estimate?

Did you ask your client if they wanted an estimate or a bid? Many people, clients and photographers alike, find the terms confusing.

An estimate is generally your offering of price for the assignment with the understanding that you are being given the job for the fee quoted, with an acceptable trade allowance of plus/minus 10 percent, although frequently more flexibility is possible (but don't assume, ask).

A bid is essentially an estimate except that you are offering it as a firm price, probably in competition with others, with price being a major part of the decision process.

Not all bids are competitive. The other type is commonly called a comparative bid, usually given out to validate a price that the client already has, is generally happy with, and may have already accepted. Occasionally your client, usually an ad agency, will ask for comparative bids in order to be able to prove to their client or boss that the first received or already accepted price is not out of line. Always ask what type of bidding situation you are in. You should

know so that you don't waste precious time preparing a detailed bid if the decision has essentially been made. On rare occasions it may be okay to submit such a bid to help a really good client, especially if the job is not your specialty and it's clear you're preparing a bid as a favor.

It is also helpful to ask against whom you are bidding; it could be that the art director really wants you because of your creative abilities. And, it could be that price isn't a major factor. If you inadvertently engage in a price cutting/bidding war you may end up depriving yourself of any profit, and damage your reputation in the process.

Finally, to ensure that all parties are preparing their bids from the same information, request that all participants meet jointly to receive the information. If this isn't practical, at least ask that everyone be sent identical specifications in written form.

Expectations

Clients are, on the surface, interested in a number of things, but chiefly they want to get a good photograph(s) for their project at the most reasonable cost. You, on the other hand, are more concerned about creating exciting images for the maximum possible income.

Try to find out your client's real expectations. In our hypothetical assignment, is Susan, the art buyer, really concerned with this job or is it really just a nuisance for her, something she hopes to dispense with quickly? That being the case, you might be able to capitalize on it by taking on (and, of course, charging for) some of the burdens she hopes to get out from under. Or, could it be that she is thinking more about her career than in making this a successful creative collaboration? If so, you could be placed under extreme pressures. If the job comes in under budget will she be promoted? This is subtle information that won't be delivered on a platter.

Most often the people you work with will be determined to do a good job; however, always listen carefully, and read between the

lines. If any client harbors serious or unspoken expectations that you fail to learn, ultimately you will be the one who is disappointed. One photographer was told he was selected by a graphic designer because of his use of color-gelled lights in one of his portfolio samples. But the designer specifically mentioned using gelled lights in only one of the six set-ups they discussed. A partial re-shoot was required because the photographer didn't realize the designer wanted gelled lights in every situation. In this case, the problem, caused by a simple lack of information, had a simple answer.

Educating the Client

An important issue is the on-going education of those who buy the rights to and use your photography. Not only can you improve your negotiating prospects but you can cement a long term relationship. It should be obvious, though, that you will be walking a fine line—always treat your client with respect while you explain industry practices.

Note: just as important, take time to educate your fellow photographers. Many of them are not well versed in these issues and could use your assistance and ideas. If all of you are playing by the same rules it shouldn't be perceived either as restraint of trade or helping your competition; it will simply be making the entire playing field a better place for all.

And what do clients need to know?

Explain the value of your work in relation to the assignment. "I suspect it may seem like a lot of money but let's keep it in perspective. My photography will occupy eighty percent of the space in your ad, yet it is costing you less than five percent of the total project!"

They also need to know when pinching pennies can actually be more expensive. "I understand a helicopter is more money, but, if we have to move a crane for a different angle, as I suspect we will want to, it will take longer, therefore costing more." Here is a fa-

vorite of tight-fisted buyers: can you afford to not have assistants? You can't leave your equipment and chase people down. Cutting pennies by cutting assistants is generally more expensive in the long run.

Why not educate clients by making an offer that will make their life easier: convince them that next time it will be to their advantage to call you first, for an estimate of photography time and costs before they prepare their project estimate. This idea also has the added advantage of giving you the first foot in the "assignment door."

Usage rights

An area where conflict commonly arises, conflict that could also be avoided by education, is the issue of how the photographs may be used. Since they pay for the photography, including film and processing, many clients therefore assume they should possess all right and title to the images.

Photographic reproduction rights licensing is little different from many other types of business. If confronted with the question, "I bought it, why don't I own it!" you might ask if any other supplier would ever give such an open-ended purchase? You might ask, "Doesn't your printer charge you for additional press runs?" Or try, "When you rent a car it's only for a day, or a week, and not forever, isn't it?" You can also remind them that magazines charge each time their advertisement runs; one payment doesn't entitle them to unlimited insertions of their ad.

Sometimes, some clients will try to carry reuse concerns to extremes. "But if you move, I can't find you and I need to negotiate an additional use..." Don't hesitate to point out that you are a professional and here for the long haul. It's usually best to confront their problem and offer an immediate solution. "I understand your concerns. Let's negotiate this now. Do you think you would want to reuse the photo in another annual report? Or would it be more likely

used in an ad? Let's try and determine what you might need now and in the future; there simply isn't any point in your having to pay for uses you will probably never need."

Should there still be an insistence on open-ended or extremely long term rights—usually called a Buy-Out or All Rights (see "Caution About Terms" in chapter 8)—let them know that their demands will, of necessity, cost more, unnecessarily. Clients who are unsure of the length of usage time needed and who try to shield themselves with All Rights agreements are trying to take the easy way out. Someday, ask a client when the last time was that they reused a photograph after a year or so had gone by. It doesn't happen often and you could easily grant them additional time without giving up all right and title to your work. Again of course, they should pay something more.

Or, perhaps they say they need an open time frame or possibly All Rights in order to protect a corporate or product image that they are developing through the use of your photography. Don't be afraid to explain that more than likely they are again just wasting money by paying for All Rights. And, being a good negotiator you will immediately inform them that you can offer the protection they seek, and for less money than All Rights would cost. Suggest some form of protection, such as agreeing not to allow a competitor to use the photograph(s), or possibly offer to withhold an assignment's images from stock sales for a certain period of time. Satisfy their concerns, save them money, but always charge for their requests.

Of course, just like actors who agree to exclusive contracts and who are not allowed to work for other advertisers, you too will have to charge an additional fee(s) as compensation for the loss of income that could have come through stock sales of the image(s) during the period when use was reserved.

Work for hire
An area that many clients have become educated about over the past few years is that of work for hire. However, some confusion still exists. (Please consult Chapter 1 and the books in the Bibliography for a larger discussion of work for hire.) Since the Supreme Court decision in 1989, favoring creators, it has become quite difficult for clients to claim your work as work for hire without a written contract beforehand. If they try, and they may, it will be incumbent upon you to explain the reasons why work for hire is not to anyone's advantage. Remember, many clients' problems will revolve around:

- Protection: not wanting photographs they commissioned to be used by competitors,
- Reuse: having or being able to obtain permission or reuse easily,
- Not having to renegotiate: mostly they don't want to pay extra for reuse.

It may just be that they are thinking work for hire because they just don't know any alternatives. As discussed before, why not offer: (1) to withhold the photo(s) from stock sales for some mutually agreeable period, (2) to protect them from usage by competitors, (3) the option to negotiate for reuse up front, thereby avoiding negotiations and/or additional fees later on.

Never forget, work for hire is too expensive a proposition for either of you, client or photographer.

Quoting the Price
Photographers should give careful thought to how they present pricing information to their clients. Determine a way which won't either damage your own position or trigger excessive concerns in the buyer. The only unbreakable rule is that every estimate, or bid, should always be submitted in writing. It is the single best way to eliminate confusion and guessing.

Don't forget, the negotiation process doesn't really end until the invoice is paid in full.

Breakdown of fees and job costs

Your every written estimate (and all delivery memos and invoices) should include a statement describing the assignment as you understand it. It should also clearly state the usage rights, a statement of copyright retention by you, and any factors that may affect payment, like a service charge for late payments, and so forth.

It probably isn't advisable to itemize each and every job cost. Your paperwork will become too complex and there can be distinct disadvantages.

One has to ask what can be gained by such an itemized approach? Will your client be made any happier knowing exactly what you paid for things? One photographer, for instance, who itemized every roll of film, had an invoice rejected when a corporate "beancounter" realized how much less he could buy film for at a parking lot/one-hour photo lab processor. Will your client really understand that your film, a more expensive professional emulsion, was refrigerated at the dealer, tested by you, and stored again in your freezer, which is one reason why you are charging more? Or, will they be happy to see you are adding a markup on your expenses?

Have you ever considered what makes a client think they own the images when they see film and processing costs detailed on your paperwork? Many photographers find it better to simply list expense items under broader, more general categories. For instance, film, processing, prints, Polaroid for testing, and so forth may be best combined under: "Film & Processing" or "Sensitized Materials." Mileage and local transportation costs could likewise be grouped under: "Location Expenses."

It could also work to your benefit if you include, on every invoice and estimate, a standardized list of expense categories. Even though not all jobs will find entries in every expense category you are subtly telling your clients that they will be responsible for reimbursing you for any job related expenses.

Bottom line price only

Some photographers quote a bottom line price only, finding it to be an advantageous way to price and a logical extension of their concerns about itemizing expenses.

Prepare your estimate of fees and costs in great detail, but only for yourself. Your client will receive, instead, a proposal showing only the total amount for which you expect to be able to do the assignment.

Why should clients know what you paid for things? Ultimately, shouldn't they really be concerned with just two things: whether or not you can provide the photographs they need, and at a price they can afford? An example: if you allow a client to become involved in your pricing decisions who, for instance, will decide how many assistants you need? And who will assume the blame if the decision is wrong? If you break down expenses, some buyers will attempt to negotiate (or dictate) every little expense you have included. You can't afford to let this happen.

Clients always have the right to reject your quote if it is too high for their budget. Should that occur, the bottom-line-only estimate offers an advantage. It allows you to adjust your calculation of fees and expenses without tipping your hand as to what might have been cut. An estimate showing only the total price, the bottom line, can save you many explanations while allowing you to run your business as you feel it should be run.

Receipts

A related problem is that of presenting receipts for expenses incurred in the production of an assignment. If you decide that you don't wish to tell your client what you pay for things you can frequently negotiate an arrangement. Photo buyer, "Bob, when you bill us for your photography, make sure to include the original receipts." Why not counter with "Susan, normally I'd like to help but my ac-

countant demands them for the IRS. Besides, I've quoted a firm price based on the job as you described it. It shouldn't matter what I pay for supplies, as long as I don't exceed the total amount we've agreed to." That usually works; don't be afraid to try it.

Some ad agencies demand original receipts and you may have to decide if you are willing to play along with them. If pressed for the receipts you might add "If my actual expenses run lower than the estimate, I'll charge you less." Seldom will a client refuse that trade-off.

Pricing on a per shot basis

Certain types of photography are more commonly priced by the "shot." Catalog photography is typically done this way, as might be a series of photos for an ad campaign.

The lighting and background setups usually remain the same, or virtually so, as one product after another is photographed. Because of the repetitive nature of catalog photography or of the possibility of shooting many days for a campaign, you may find it advantageous to charge a slightly lower Creative Fee. However, only offer this if it gains you some advantage, such as ensuring you get the job. Don't give away the store and don't do it for only a few days or a few shots!

Closing the Deal

Don't be surprised or pessimistic, your quote may be right on the mark and instantly accepted. If not, however, renegotiate. And, renegotiate again, if need be.

Because many people are unsure of themselves during the negotiation process, some can be pressured into cutting their prices without a concomitant offer from their opposition. To do so sends the message that you aren't terribly sure of your business skills and that you can easily be driven down again in the future. Always have

a valid reason for price reductions or for anything you give up in a negotiation.

But what if your client rejects your estimate as too expensive? First, ask yourself, is this estimate really accurate? If it is, and if you do have to renegotiate your price, you are still in a good position. Don't worry and don't give up. Tell your client that, since your estimate is fair and accurate, they too will have to give up something— extra rights, variations, number of models, etc.—to achieve a lower price. It is poor negotiating, not to mention illogical, unreasonable, and irrational to give up something without also requiring the same of your client. That is why many negotiators prepare a comprehensive proposal covering and charging for every possibility in their first offer, knowing they can then trade away what isn't absolutely mandatory.

And, make sure your client understands, and that you control, the effect of cost cutting on the quality of the project.

Every aspect of an assignment estimate is negotiable. Don't dwell only upon the monetary facets or you may set up roadblocks to success. Ask whether or not your client really needs all of the usage rights they have requested. You can probably charge less if they don't. Or, perhaps you can offer more efficient and less costly ways to accomplish the assignment. Someone should ask, "Is it really necessary to travel to every division of the company?"If you get to the point where you can't change the assignment's parameters, and don't have room to move monetarily, don't be afraid to say so. Letting your client know you are unable to further reduce the price tells them one of two things: it is time for them to accept your proposal, or that they can't afford you and you can't afford them!

In effect, you have told them "no"; no more reductions, no more negotiations. Let's face it, you won't be able to get every assignment you hear about nor, on the other hand, will you be able to afford to do every assignment. Being an astute businessperson, you will have to reject some as being unaffordable. By saying "no" you are retain-

ing control of your own destiny, by acquiescing to further client demands you are giving it up.

In a negotiation, never forget that you are committed to an amount below which you will not go. Learning to say "no" gracefully is a negotiation skill that must be practiced, and used. "I'm sorry we can't come to terms. Perhaps some other time we'll be able to work things out."

A successful negotiator is always conscious of when there is a goal worth striving for, and when there isn't, and that there are many paths available to reach the target, but it shouldn't be given away for free.

Carving it in stone

As hoped, your estimate was accepted and you've received the go ahead. Your next step is to ask for a purchase order (PO) and to send your client a confirmation.

The PO usually will contain a brief description of the job, probably a client order number and the agreed upon amount. Generally, the PO will not describe your agreement in great detail, rather it is your client's commitment to proceed and to pay. Note, however, that *the PO may also include some terms and conditions which you must read, and understand.* Be careful of language transferring copyright or giving the client rights you haven't agreed to. If the PO does have such language, you have a couple of ways to proceed.

You can cross out the offending language and discuss (renegotiate) it with your client. If you have been careful to state your terms and conditions on your estimate in the first place this shouldn't be much of a problem. The wrong thing to do is ignore the language and hope that if it does become disputable your estimate's terms and conditions will supersede your client's in a court of law. Make sure things are crystal clear at the outset.

Even though you have received a PO, get in the habit of sending a job confirmation in which you describe the job as per your es-

timate, the usage rights, and anything you think to be pertinent to the assignment, including the price and a reference to your estimate. The confirmation should include your terms and conditions as shown on all of your other paperwork. Your confirmation is a declaration of what you and your client have agreed to and the responsibilities you have to each other.

Should your client request any changes (more photos, more setups, more time, etc.), always submit another assignment confirmation or use a change order, noting the requested assignment changes and any alterations to the estimated fees and/or expenses.

Without either a client signed PO or confirmation(s), you are working and spending money based on only an oral agreement. If there should be a dispute later it will be your word versus theirs. What if something should happen to your client? Perhaps they're fired, and the replacement doesn't know anything (or care) about you or the assignment? Don't laugh, it has happened—many times.

In this day and age, even if you are called late in the day to begin early the next morning, you can still fax or express a confirmation. Your client will have the paperwork by mid morning and can call you wherever you are photographing if there are any questions or problems.

Always, get it in writing!

Follow Up

Consider follow up as part of the negotiation process because you are trying to show that you care, about their needs and about your photography. You are indicating that you value your work and your relationship with them as well as telling them that you hope to be considered for their next assignment.

Assignment Telephone Information Form

Name _____ Date _____

Company _____ Assignment Date _____

Street _____ Deadline Date _____

City _____ State _____ Zip _____

Telephone _____ Estimate sent ❑Yes ❑No Date _____

Fax _____ PO #_____ received ❑Yes ❑No Date _____

Confirmation sent ❑Yes ❑No Date _____

Final Client: _____

Use Rights: ❑ Advertising ❑ Corporate ❑ Editorial ❑ Other _____

Description (of assignment and rights granted) _____

Print Media:
Placement: _____ Size: ❑ 1/4 page ❑1/2 page ❑ Full page ❑ Double page ❑ Other _____

Number of uses: Circulation _____ Press run _____ Insertions _____

Translations (Languages) _____

Distribution: ❑ Local ❑ Regional ❑ National ❑ Other _____

Other Media: ❑ Package ❑ Billboard ❑ Other _____

Distribution: ❑ Local ❑ Regional ❑ National ❑ Other _____

Time (period of use) _____

Location: ❑ Studio Location Address _____

Number of Clients at Shoot (names) _____

Other(s) _____

Assignment Telephone Information Form (Continued)

	Name	Business Telephone	Fax Number	Home Telephone
Art Director:	_____	_____	_____	_____
Client contact:	_____	_____	_____	_____
Location contact:	_____	_____	_____	_____
Other(s):	_____	_____	_____	_____

Film: ❏ Transparency ❏ Color Neg ❏ Black & White **Film Size:** ❏ 35mm ❏ 2 1/4 ❏ 4x5 ❏ 5x7 ❏ 8x10

Polaroid type _____ **Proofs** ❏ Contact ❏ Prints

Prints: ❏ 5x7 ❏ 8x10 ❏ 11x14 Other: _____

Lighting: ❏ EXTERIOR ❏ INTERIOR ❏ Flash/Strobe ❏ Quartz/tungsten ❏ HMI ❏ Existing on location

Crew: ❏ Assistant(s) ❏ Stylists ❏ Location Scout ❏ Others _____

Insurance Provision: ❏ Self ❏ Included in Policy ❏ Rider ❏ Other: _____

Product Description: _____

Pickup from: _____ Date: _____

Delivery to: _____ Date: _____

Props description_____ Pickup ❏ Yes ❏ No Date _____

_____ Return ❏ Yes ❏ No Date _____

Rental Equiptment: _____

Set description: _____

Talent: Approvals needed ❏ Yes ❏ No By whom _____ Invoice to _____

Travel: _____

Miscellaneous: _____

43

Chapter 5

Negotiating Stock Photography

A s you approach negotiating for stock, keep in mind that you are not alone, nor are you the first. Many have gone before you over the difficult terrain of setting stock prices and terms. Since the earliest days of the stock photography business, for over 50 years, stock agents and photographers worked to forge the prices and business practices we now consider common. The term "industry standards" sums up these practices which includes everything from holding fees, research fees, to the full range of usage rights that command a fee. When you consider a first negotiating encounter with a client, know that you have on your side this body of experience from both buyers and sellers which empowers you in the marketplace to charge a fair price and maintain protection of your images and your copyright.

Start your stock negotiating, just as you did assignment pricing, using the same six steps of negotiating:

1) Establishing rapport, 2) Gathering information, 3) Educating the client, 4) Quoting the price. 5) Closing the deal and, 6) Following up. By sticking with these principles, you will know you've done everything possible to achieve a successful, fair and amicable negotiation.

Negotiating for stock differs from assignment in one very significant way: the photographs already exist. Since a stock buyer negotiates with you for specific pictures, you should base your price on:

- usage
- value of the photograph to the client's project
- value of the photograph to you

Usage

There are different prices for specific uses depending on the purpose, where it will appear, how big, for how long, how many times it will be used, the territory (distribution), the language (translation), and so on. Also refer to the box "Pricing Factors" in chapter 2 and the rights term definitions in chapter 8.

Value of Photographs

Photographs have value to users only to the degree that they solve a visual problem for them. It's important to find out just what that value is. It may not, as it seems on the surface, depend on the size of the company or their advertising budget. Imagine that you get a call from a small manufacturer of widgets wanting to use your photograph for a cover of a small print run brochure. It is their single mailing piece for the year and the most important promotion they run. In this instance the photograph has extraordinary value to them.

The same photograph used by a major credit card company, on the other hand, for one of numerous direct mail promotions done monthly may have less relative value in their promotion world.

When setting a price, find out as much as you can, then integrate all the factors you learn from a client. Keep in mind that your

perception of how crucial the photo is to this user will be influenced by the reality of their budget. But knowing the relative value will help you negotiate to the upper limits of their budget.

Value to You

Keep in mind the actual value of your stock. You can and should place greater value on some photographs than on others. Evaluate your photographs and price them based on their cost to you and their unique quality, not only on the client's intended use. It is reasonable to charge more for any photograph that involves factors beyond those considered in normal pricing.

Stock Factors

The following are those factors that will allow your photo to command a higher than standard price.

Expenses:

- Normal costs: shooting time, film, equipment, overhead, etc
- Extra costs:
 Model fees (non-pros),
 Model fees (professionals),
 Location fees,
 Props,
- Travel costs:
 Domestic,
 Foreign,
 Exotic (out-of-the-way),
- Extraordinary costs:
 helicopters, plane, or balloon rentals,
 underwater fees,
- High risk:
 for shooting from aircraft, bridges, high buildings, rock climbing, or anything that places photographer in jeopardy.

Unique Quality: unable to be repeated
Uncommon: hard-to-find photographic topics
Freshness: new material, never-before published

Use these factors to decide how to price and mention them in discussions with clients when an explanation seems appropriate.

You can't expect that clients will always understand everything that goes into a good photograph. If you make it look effortless, they may not be ready to pay for that effort unless you make it clear what was involved.

You won't want to tell war stories to every client on every stock sale you negotiate. Just keep clear in your mind the cost, effort, and special vision that go into your photographs. An acute awareness of these factors will build your confidence when negotiating, and you'll be well prepared for those occasions when it is appropriate to share the information with a client.

Premium Pricing

Prompted by this understanding of the varying value of photographs, you may want to use a technique called "premium pricing," to distinguish photographs that are worth more than normal. You may have photographs that might appear similar to a buyer in content and style; for example, a family group at dinner. But you know that considerable extra cost and effort was needed to produce one of those family dinner scenes. It may have required extra model fees, transportation for models, meal costs, or a location fee. Further, perhaps the photographs are fresh, not previously published material.

You can charge more for these photographs and set them apart by stamping "premium price" on each slide mount. You should then provide an explanation on the delivery memo that "premium" photographs carry an additional percentage above the standard reproduction fee for the usage. Twenty-five to fifty percent is a common range for the surcharge, but it depends on the value you place on the photos.

If the photographs have a similar look and the same value to the buyer, why should they be willing to pay more? They might not. It is their choice, although you can surely influence them. If they don't perceive any additional value in the premium photo they will choose another. But if they get the benefit of the freshness, extra costs, or effort in a premium photo, then you will be receiving a fair price for its use.

Quoting Stock Prices

Prices are sometimes discussed when the buyer is making the initial photo request. Other times, such a discussion occurs when they actually have your photographs in front of them, either under consideration or actually chosen for use, an ideal time because they are already predisposed to your picture!

Avoid getting locked into a hypothetical price because different photographs command different prices based on the specific usage and on their differing production costs. Although offering a price in the abstract may seem innocent the price may become solidified in your client's mind, thereby endangering later negotiations.

Before entering a negotiation, set a bottom price below which you will not go. It may be tempting to make a deal at all costs. However, saying "No, thank you" and walking away with your bottom price intact is one form of successful negotiation and the only way to ensure that your work doesn't become devalued because of lowering your price.

Talking price can be simple and straightforward. Sometimes a buyer will state the normal feel they pay for a usage and it will be well within your own and industry standards. Or you may receive a billing request letter or purchase order stating their price. Again, if it is reasonable, the transaction becomes merely paperwork.

At other times, you may have to seize the initiative. If, after discussing the photo request, the buyer doesn't mention money, you should open the subject with "Let's talk for a moment about the re-

production fees." That will usually bring you to one of the two most common approaches to price: the buyer asks, "What do you charge?" or says, "This is what we pay." Some photographers state a price at this point, a foolish move. The buyer will occasionally have a higher budget than you anticipated, so you may have given away an extra percentage by jumping in prematurely.

Taking time

You don't need to rush a price quotation. Are you obliged to give an immediate answer on a price? Not at all! And don't fall for the old line, "Just give me a ball park figure." That ball park could become your prison.

If you need time to think, get off the phone. Tell them you'll get back to them. Give it ten minutes while you consult the charts in this book, calculate your value factors, or call a photographer friend. Use any ploy you must to get breathing room. If you can't think of anything else, there's always the old standby, "I'm involved at the moment, let me get right back to you."

But first, find out how long you can take to get back to them without jeopardizing a sale. Listen to the client's signals. If your comment, "I'll call you before the end of the day," provokes hesitation in the buyer's voice, counter with, "Look, let me see if I can cut this meeting short. Maybe I can have something for you in a few minutes."

See what you can learn about the client's budget before you commit yourself. Don't ask what they can pay. That puts you in a yes or no situation.

Without asking it directly, find out what they have budgeted before you answer their question, "What do you charge?" To get a response from them, float a trial balloon. Quote a price range. If they gasp, you've learned something useful, but make sure it isn't because you set your lower price too low! You should quote a wide range so that their price is likely to fall somewhere within it. Also, you need room to maneuver. They may even blurt out their budget at that point.

If they hedge, you can ask them to give a price range. Here's how you might answer the typical buyer's question, "What do you charge?"

Photographer: "Well, I have a range of fees depending on a lot of factors, including usage, the difficulty to produce the picture we're talking about, and so forth. In my experience, a fee to cover your requested usage can range from $400 to $1,000, depending on the reproduction size, the intended circulation, and the number of pictures you are using from our file."

Buyer: "We never pay more than $200."

Oops! Now it's time for the good cop/bad cop technique. It's been said that there are always four people in any negotiation: the buyer and his or her boss (the authority who approves the money) and the photographer and his or her boss. If you have a partner (or an accountant or a financial manager) you can use this technique. Professional negotiators say that you should never negotiate with someone who isn't in a position to make decisions. In reality, that may not be possible. Either way, you can still use the good cop/bad cop position on your end.

You become the good cop. Photographer: "I wish I could give it to you for that fee, but I may have to check with my partner. We've agreed on a rate schedule, so let me see what I can do."

Get off the phone. Make your decision, and call back with an answer. If you can't live with their budget, blame it on the bad cop, your partner, your business manager.

If you do choose to work within their limits, take credit for it. Always give a reason and if you lower your price make sure you get something in return, whether it is reduced usage on the part of the client or a number of tear sheets for your portfolio. Never leave the impression that their take-it-or-leave-it intimidation worked.

Until you get right down to a decision, keep the discussion open and fluid. Present options. Imply to the caller that there is always a possibility for agreement.

Negotiating Conversations

In picking your approach to negotiating, no matter what words you choose, remember to communicate, that you want: to conclude a mutually satisfying deal.

Here are some phrases from hypothetical negotiations. Find the ones that are comfortable for you, that adapt well to your situation, then translate them into your own language.

One important phrase is: "As I'm sure you understand..." It's especially useful when you suspect that they don't really understand the business. You are attributing to the listener an education or awareness they may not actually have and it prepares them to receive your information in a more neutral way.

That brings us to the next most valuable phrase, "Let's see how we can work this out..." Often this is most effective when ended with a pause which shifts the pressure to respond over to your negotiating opponent who may blurt the answer that you both need. The buyer may well answer with something similar to "I could probably get them to go up to $xx but I'll have to check."

Pose some questions: "Let's see how we can make this work...(pause)...Are you planning to use more than one picture? Do you have other picture needs on this project? Are we speaking of a volume of photographs? How about upcoming projects, do you know your needs in the next months?"

Once they pick up on one of those questions, your negotiation is still alive and you've steered clear of the "take it or leave it" waters.

What to say when they rush you

I'd like to give you a fast quote, but I have to have a bit more information. I want to be accurate about the rights you need. As you know, that affects the price and there is no reason to charge you for anything you don't really need."

Expressing concern over price

"As much as I'd like to help you out, I simply can't go much lower. It's because this particular picture is one of my XX collection. You know how expensive that can be, what with extra model fees, props, travel..." Or try, "Since it's going to be tough to come down much further, let's see what else we might work out..."

Always give a reason when you adjust your price

"In this one case we're going to bend the rules a bit to help you out. The project sounds interesting and out of the ordinary, and you are using quite a volume of work. After you've published the photographs the reprints will help with our promotional efforts. I'll call you and tell you how many we'll need."

Educating them to the realities

"I'm sure you're aware that the standard fee in the industry for this usage is $xxx and can be as high as $+++. Since I understand that you have a low budget I'll try to accommodate. I can go as low as $yyy, but I'm not sure how much more I could do..."

When you have to enlighten them about your costs of business, try: "I'd really like to help you out, but one reason it's tough to go as low as you want is that I need to keep reinvesting in my stock. I hope that each time you come back to me, I'll have fresh new material for you. It's impossible for me to continue investing in new photography if I don't maintain a certain price level. I'm sure you understand."

These approaches must avoid any hint of whining. References to your high costs must be unemotional and matter-of-fact, not bids for sympathy. One business person to another.

When you have to say no

"I'm afraid that is lower than I can afford to go. Thanks so much for calling. Sorry I couldn't help you out this time. Hope I'll be able to provide something for your next project. Do you have one of my updated stock lists? Let me send you one."

Myths

Once you have the basic information needed to negotiate and price your work from a position of strength, there are some myths held by clients that need to be dispelled. Here are a few:

Myth One: An individual photographer should charge lower rates than a stock agency. The reasoning from a client goes like this: "If you sell through an agency you'll only get 50 percent, so why are you charging me full price?" This argument doesn't cut it because the client is paying what the photograph is worth to them: for the usage they are requesting and because it solves a problem. It has an established value to the buyer's project regardless of its source, your files or an agency's. Questioning your right to the additional 50 percent on the basis that your overhead may be lower is presumptuous and erroneous. When you provide photographs directly to a client you are bearing all the costs of captioning, labeling, filing, logging images in and out, remounting, and billing, as well as using your expensive office equipment, just as an agency would. Though you may not be located in New York's Photo District, the Near North in Chicago or Wilshire Boulevard in Los Angeles, your overhead must be covered. Why should a buyer consider it acceptable for a photo agency to recoup these costs but not an individual photographer? Perhaps it is merely a client-negotiating technique to save their company some money? Keep in mind that you are running a stock business that has its own overhead and don't be afraid to explain that to clients.

Myth Two: Bartering makes sense if I gain access to a good location for stock shooting. This is faulty thinking. In the long run you may be taking a deep cut in your stock sales. Some photographers

trade rights to a portion of a shoot, turning over a certain number of actual images, including all usage rights, to companies that provide the opportunity for photographing on their premises. This is a very dangerous practice. You are sending the wrong message about your photography and its value when you trade off all rights to any photograph.

You can use complimentary prints, limited reproduction rights, and other means as a fair exchange with the administrators at an institution or location, all without giving away the rights to your work.

Be wary of turning over a segment of the shoot for nothing more than access to a location or you could end up competing against yourself someday. Imagine that you did some barter photography in order to get permission to shoot stock photographs at the facility of a friendly small company in your city. Later that plant merges with a huge corporation. Your "freebie" photographs are then swallowed up in the vast corporate photo file, for use without payment by every subsidiary of the corporation, to be given away free to outside photo buyers for public relations purposes, or even to be sold through a photo agency! And you won't receive a penny's share of those reproduction fees. The Copyright Act of 1976 gave photographers ownership of their work. But the law can't protect you from giving it away foolishly.

Myth Three: A beginner has to take what he or she can get and give away work in order to be published. Before accepting that premise ask yourself if you are a professional and want to be perceived as one. Remember that the minute you sell a photograph you are in the profession, even if it's not your full-time job. What you owe to the profession you are entering is respect for your own photographic work. One way of showing that respect is to require it in turn from editors and art directors.

Should you make more concessions on fees than an established pro? That's the nature of breaking in. But do your price adjustment with a professional's cool appraisal, understanding that this is the reality of starting out.

Finally, let's put an end to the notion that it is reasonable or necessary to accept whatever you are offered, especially a bottom-of-the-barrel price, for the use of a stock photograph. This is true for a beginner in the field just as much as it is for an established pro.

One danger in accepting any price in order to break in is the difficulty you'll encounter in changing the buyer's perception later on about your value. How are you going to convince the buyer who got your photo for peanuts last year that it's worth more now?

Assess each situation on an individual basis. Everyone recognizes that there is a difference between the price an advertiser can pay for a photograph that will sell their product and what a small circulation magazine can pay for editorial use. A beginner may choose to charge somewhat less, both for the experience and the tear sheets, but not because they are forced into accepting the lower rate. Your concept of the photographer/client relationship is an important clue as to how you view your position (power and rights) in a negotiation. You charge, you don't accept. You can give a lower price, but you don't take a lower price. You can offer, but you aren't forced.

Myth Four: Since the picture already exists, it's better to get something than nothing.

The "it's just sitting in the file so why shouldn't I sell it" premise is dead wrong. That attitude always communicates a subtle message to the client, that each time you'll accept a little less because "it's better than no money." Clients will begin to force you down to zero. Remember the farmer who thought he was being so canny when he trained his horse to eat a little less each day? He had just about succeeded in getting the poor animal down to nothing when the durn critter died.

Telephone Stock Request Form

Request Date _____ Photos needed by (date) _____

Name _____ Tel _____

Company _____ PO # _____

Address _____ Job # _____

For (end user) _____

PROJECT TITLE _____

			FORMAT:		
USE:	❏ Advertising	❏ Editorial		❏ Color	❏ Horizontal
	❏ Corporate	❏ Other _____		❏ BW	❏ Vertical

CONCEPT/SUBJECT _____

USAGE/RIGHTS **SHIPPING VIA:**

Use in _____ Client Courier # _____

Size _____ Date Sent _____

How many copies _____ Via _____

Where (United States) _____

Other _____

❏ English Language ❏ Other Language(s) _____

Media buy _____

PRICE: Our Quote _____ Client Budget _____

FINAL PRICE _____

Chapter 6

Pricing Assignments

Y ou have learned new techniques and are ready to begin honing your negotiation and pricing skills. Now, the final steps, putting it all together into an estimate of price.

To be able to present your assignment estimate you have to put together a number of factors, all of which are vital. Creative Fees, Other Fees, Billable Expenses and any applicable Miscellaneous Charges are all combined to arrive at your total assignment price.

At this point, since you have the specifications for an assignment, it would be wise to draft a few simple declarative sentences or paragraphs describing the assignment: the usage rights required; the time period for photography—the billable time; and any other specifications, if they help define the assignment. By referring to this statement (which you will include in all of your paperwork to your client) and the Telephone Information Form, you can remain focussed on the vital elements of the assignment that will affect your pricing decisions.

Creative Fee

As you remember, your Minimum Daily Fee is the amount, per billable photography day, which covers overhead and profit. Also remember, it is only one element of the Creative Fee. Once you know your Minimum Daily Fee it can then be multiplied by the number of days you can actually bill for photography during an assignment. The total is then adjusted by the usage and value factors found in the box, "Pricing Factors" (see chapter 2), and becomes the Creative Fee.

Applying values to these Pricing Factors is made possible through experience, a knowledge of the industry, and, especially and importantly, by talking to other photographers. The pricing charts in chapter 9 will also help you better determine whether or not you are in the range of what other photographers have found to be obtainable.

Other Fees

Other Fees are those, listed below, such as travel, weather delay and production fees, which will compensate the photographer for time spent on behalf of the client's assignment—keeping you away from family and other paying work.

All or some of these fees may apply, although usually not on every job. As mentioned in chapter 4, you could keep your paperwork simplified by showing only the fees that are actually incurred or, as suggested, list all potential Other Fees as a client educational tool, whether incurred or not. It's worth considering.

Pre- and post-production fees

You need to be compensated for significant time spent by you (on behalf of your client and the assignment) before and after the actual photography (production). These pre- and post-production fees cover: meetings with the client, time spent making arrangements, editing and captioning large amounts of film, set or location restoration and cleanup, and so forth. Most photographers' creative fees

Writing a Usage Rights Statement

These are hypothetical but typical assignment usage specifications. Some of them, like size and time, are imprecise due to the nature of the business, but their importance in your calculations is in no way lessened.

Assignment specifications:

Placement: 1993 Annual Report, ABC Corporation, cover and inside; possible slide show for in-house use

Size:
Annual Report: varies
Slide Show: not applicable

Number of Uses:
1993 Annual Report—one time only
Slide Show:
show #1: 4 times
show #2: unlimited

Press Run/Circulation:
1993 Annual Report: less than 100,000 copies
Slide Show: not applicable

Time:
1993 Annual Report only
Slide Show:
show #1: up to one year
show #2: indefinitely, for new employees

Distribution:
Annual Report: United States only
Slide Show: United States; subsidiaries in
England and Switzerland

Translation versions: English only

Miscellaneous notes:

This annual report will have one press run but the corporation will undoubtedly use it for over one year, mailing it out to investors upon request. This doesn't mean, though, that they can reprint the annual report or use the photograph(s) in any other way without your permission. On the other hand, the slide show will be run four separate times over the next year, and probably be incorporated into a long-term slide show for new employees.

Sample usage rights statement:

These terms can be combined into a simple statement and used on all paperwork sent to your client:

"The photographs of Joe Smith, CEO and of the milling machine operator of the XYZ Corporation are for one-time, nonexclusive use, only in the 1993 annual report of the ABC Corporation, parent company of XYZ. They may also be used only in an audio visual slide show for up to one year for employees and sales staff of the ABC Company and its subsidiaries in England and Switzerland and indefinitely in a similar show for new employees. All other rights are retained by photographer."

(Also see box: Pricing Factors, chapter 2)

incorporate a certain amount of time for normal pre- and post-production time; it is your decision when to begin charging additional fees for excessive time. Don't be intimidated into not charging, and don't give it away.

Casting fees

The time spent by the photographer when involved in locating and booking models and talent is compensated through casting fees. You could incorporate casting fees into pre-production, but it is usually best to separate them. Staff time, for casting, should be expensed along with all other assignment expenses, including that of an independent casting director. The Casting Fee represents only the photographer's time.

Travel time fees

Frequently, photographers will bill all or a percentage of an assignment Creative Fee "day" for travel, these "days" being calculated as the Creative Fee total divided by the number of assignment days you actually invoice. For instance, if the Creative Fee for a two-day assignment was $5,000, the hypothetical "day" would be equal to $2,500. (Caution: if you use the Minimum Daily Fee you won't be compensated fully for your time.) Staff time for travel is always expensed.

Travel generally means a distance greater than fifty miles from home base or an overnight stay. Transportation, on the other hand, is local conveyance (cabs, commuting in your car, etc.) and is always expensed, as are the actual costs of travel.

Weather delay fees

Photographers going on location may find themselves waiting for weather: for weather to pass by or for specific weather to happen for their photography. Either way, you must be compensated for time spent on behalf of your client.

Billable Expenses

The following expenses, incurred in the process of completing an assignment, are commonly billed to the client. As mentioned before, it is generally wiser to group expenses, like Sensitized Materials or Crew, on your paperwork and not list each separate expense. If you are quoting a bottom line price only, always note on the forms that all expenses are included in the total number, in order to avoid confusion.

The following are commonly acknowledged expense categories:

Casting: any costs involved with locating and signing models—Polaroids, casting director, research, staff time...

Crew: assistants—photo and otherwise, carpenters, stylists, model makers...

Sensitized Materials: cost of film, processing, Polaroids, prints, contact proofs...

Insurance: the actual cost if obtained directly for your client's benefit or prorated per billable day if you routinely carry the policy—liability, special coverage (like film stock defects, camera failure, theft...)

Location: scouting, transportation, fees and permits, staff time...

Miscellaneous: gratuities, meals during photography, phone calls...

Props: purchased or rented objects required for photography but not the actual subject of photography. Since few photographers will factor it into their Creative Fee calculations, if props are purchased or owned by you, consider "renting" them back to yourself for the assignment, charging the client accordingly.

Rentals: anything that is rented for an assignment (other than props), from fog machines to studios to longer or wider lenses than you own. If you do own specialized or highly expensive equipment, recoup your outlay by "renting" them back to yourself.

Sets: any costs associated with planning, constructing, maintaining, and using sets where photography takes place.

Studio: expenses associated with studio operation applicable to the assignment—rental, utilities, percentage of insurance(s), and so forth. They are usually prorated if you are the owner. Or, instead, why not "rent" the studio to your client by the day for a flat fee. If you do this, be careful not to "double bill" by including studio costs in overhead when calculating your Minimum Daily Rate before calculating your Creative Fee for any one job.

Shipping: any costs incurred transporting materials or information related to the assignment.

Transportation: local commuting only—cabs, auto, parking, tolls, etc.; could also be placed under Location if related to a location assignment.

Travel: generally transit over fifty miles away or that requiring overnight lodging—includes airfare, meals, lodging, per diem, and so on.

Talent: people (models) and/or animals used in photography. Because costs can be high it is best to obtain an advance or have your client handle these costs directly.

Miscellaneous Charges

These charges are vital to your economic health and should not be overlooked. Other professionals in other industries don't hesitate to charge for them, or to use them as a point of negotiation, so why don't photographers?

Markup

A growing trend among photographers is one of applying a markup on billable expenses to compensate, somewhat for paperwork, but more importantly, for the period in which the photographer's money is paid out on behalf of a client, not earning interest or not available to work for the photographer in other ways. While some clients may balk (and why would you tell them?) this is a routine business procedure in virtually every other industry. Photographers have

been slow to recognize it and thus have lost untold amounts throughout the years. They have been, in effect, financing their client's projects. If your client objects to a markup, the not unreasonable trade off is to have them prepay expenses with an advance. Photographer (to client): "If you would like to save money by avoiding an expense mark-up, I'll need an advance, in full, on all expenses before we begin the photography." Too often, photographers who haven't tried this approach say it won't work. But how do they know?

As to how much to mark up billable expenses, again it is an individual decision. Retail businesses traditionally double the price of products they sell, while advertising agencies mark up services they supply to their clients, an average of approximately 17 percent.

Postponements and cancellations

Postponements and cancellations are two sensitive areas and, when they occur, will cause you great unease. However, business is business. When your client postpones or cancels an assignment, charges are levied to compensate you for lost booking time (which you can't easily replace with another job), and for the time spent making arrangements on behalf of the assignment.

Be very careful. You, in turn, may be similarly charged by assistants, stylists and others whom you, in turn, booked to work on the assignment for you.

Any expenses you incur, up until the date of postponement or cancellation, are billable to the client.

A postponement is generally considered a temporarily cancelled assignment that is to be rebooked within thirty days. Always obtain a signed confirmation of the rebooking (purchase order or your form, signed by the client), otherwise consider it a cancellation and bill accordingly; postponements have a strange way of becoming cancellations.

Because postponed assignments will later be completed, the penalties charged are somewhat less severe than for cancellations.

Assignment Price Calculation

OVERVIEW:

To arrive at an Assignment Price Total, calculate and add together the:
+ Creative Fee (see section A)
+ Other Fees subtotal (see section B)
+ Billable Expenses subtotal (see section C)
+ Miscellaneous Charges subtotal (see section D)

= Assignment Price Total

A: Creative Fee equation

$$\text{Minimum Daily Fee} \quad \times \quad \text{Assignment Biliable Days} \quad + \quad \text{Pricing Factors} \quad = \quad \text{Creative Fee}$$

B: Other Fees equation

+ Pre &/or Post Production
+ Casting
+ Travel Time
+ Weather Delay

= Other Fees subtotal

C: Billable Expenses equation

+ Casting
+ Crew
+ Sensitized Materials
+ Insurance
+ Location
+ Miscellaneous
+ Props
+ Rentals
+ Sets
+ Studio
+ Shipping
+ Transportation
+ Travel
+ Talent

= Billable Expenses subtotal

D: Miscellaneous Charges equation

+ Expense Markup
+ Postponement/Cancellation Fee (if needed)
+ Re-shoot Fee (if needed)

= Miscellaneous Charges subtotal

55

Re-shoots

Probably equally sensitive is the question of reshooting an assignment. It can come at the request of the photographer, the client, or by mutual agreement.

If the photographer deems it necessary, generally there will be no additional Creative Fee, although additional expenses may be negotiated with the client. However, if the photographer has actually failed to produce usable photographs, then most often any additional re-shoot expenses will be the photographer's responsibility.

On the other hand, if the client requests a re-shoot you first must determine and agree upon why. If it was due to a failure to perform on the part of your client, then an additional full Creative Fee and all extra expenses are traditionally paid. They also would be if the client requests changes or variations in the assignment that were not originally specified. If you were at fault, the above information about photographer failure applies.

There is a middle ground, where both parties are dissatisfied to some degree and agree to share in the risk of assignment photography. This commonly arises when there is damage to the film stock, perhaps through faulty processing at the photo lab.

One unique way to guard against such a loss is by purchasing film and processing insurance, currently available only through ASMP. It is a members-only benefit that could save you untold anxiety.

All of the above assumes, of course, that you can re-shoot the job. If that is impossible, and you and your client are still in general agreement that neither side was directly responsible for the lack of success, then it is traditional for the photographer to accept half of the Creative Fee and all expenses for the re-shoot.

In the event that the bottom has totally dropped out and you and your client can't even agree on what day it is, then you can always resort to arbitration, lawsuits, or pistols at dawn. All, however, will prove to be extremely expensive, and very messy.

56

Postponement/Cancellation Charges

The percentage is multiplied against the assignment Creative Fee.

All sums expended for the assignment, including items on charge, up to the time of the postponement or cancellation are reimbursable in full.

Time before Assignment	Postponement	Cancellation
24 hours	100%	
48 hours	50%	100%
72 hours	25%-50%	75%
more than 72 hours	——	50%

Example:

A postponement is received, less than forty-eight hours but more than twenty-four hours, before the assignment was to have begun. The estimated Creative Fee was $1500, and expenses up until this time were $95.

Creative Fee $1500 x 50% = $750
Expenses to this point: $95 = 95

Total to be billed for postponement = $845

Chapter 7

Pricing Stock

ell, enough talk, finally I've gotten to the prices. And since stock is much less complicated than assignment pricing, I can just skip right to the charts and find a price. That's handy."

What's wrong with that thought? Everything. Stock is different from assignment, but not less complicated. And, it is equally fraught with dangers, like the impulse to sell at any price just because it's "better than having it sitting in the file." You cannot repeat to yourself often enough, it should be a mantra in the business, "Something is **not** better than nothing! Something is **not** better than nothing!"

Is it handy just to go to a price chart? Yes, it would be an easy way to price, but anyone making a living as a photographer knows there is no easy way. Photography is a challenging and interesting profession. But you will never understand the dynamics of the business if you just grab the prices from the chart without first understanding and practicing the advice in the preceding chapters.

You will hear many of us preach this doctrine of negotiating. It's tedious to hear it over and over again. Negotiating is complicated work, but it's the only way.

Looking Foolish

If the economic arguments don't convince you, then maybe the possibility of being embarrassed will. If you grab a price from the chart without understanding the reasons for it, and can't articulate them with conviction to a client, you could find yourself in an awkward situation.

How will you respond to the client who says, "Why on earth would you charge me that much, I can get this sort of picture anywhere?" If you've carefully reviewed the value factors for the photograph in question it will be easy to answer: "Well, it may seem that pictures of business people are relatively common, but this photo features Hispanic executives, including a Hispanic business woman (which I know from other requests is not easy to find). Also, it was more expensive than normal to produce because of extra model fees, as well as a location fee for shooting in that elegant room. Finally, it has never been published before, it's fresh, never before seen, which is a rarity in stock." Without this kind of information in mind, you could be mumbling an embarrassed retreat when confronted about your price.

How To Use The Price Charts

The Price Charts are a handy reference intended to show you the range that other photographers are using. Once you have figured your own price on the Pricing Worksheet, look to see where you fall in the charts. If you are dramatically off, in either direction, go back and reconsider the factors which affect value and price. However, there's no reason why you shouldn't price higher than the charts if the picture warrants it. But if you're being guided more by wishful thinking than realistic value, you may lose credibility with a client.

Remember our premise, stated in various ways in this book:

- A price list is only a framework,

- Prices are not carved in stone,

- This price list only provides a range from which to negotiate.

Value added factors

The various factors that give each stock picture different and often additional value, above the usage fee, are listed in chapter 5, "Negotiating Stock Prices." They are also listed again on the Stock Pricing Worksheet. Don't ignore them. They represent valid charges that may be the very things that keep you in business.

Paper trail for pricing

Once you and a client have come to verbal agreement on a price, get it in writing. Ask the client for a purchase order. If that's not their policy then just send your invoice with the granted usage rights carefully spelled out. If you do get a purchase order, consult your notes on the Pricing Worksheet to check if the price and usage rights on the PO are what you agreed upon in discussion. It happens that strange, unaccountable terms sometimes appear in boilerplate language on purchase orders. Corporate accounting policies may be the reason, but you should accept only what you've agreed upon with the photo buyer.

Be sure to use professional forms (see Bibliography for several excellent books with sample forms) which include terms and conditions.

Usage

You'll see, in chapter 8, a rundown of most usages and terms that are commonly used in the business. And, chapter 6 has a box, "Writing a Usage Rights Statement," explaining how to construct a sample usage rights grant of license.

Stock Pricing Worksheet

Use the Stock Pricing Worksheet form to make notes of the factors that affect your price. There are three general areas to consider which will influence your pricing:

- Usage,

- Value factors of the photograph, and,

- Client factors.

Usage information should have been noted on your telephone form in your initial conversation with the client. These items, which include rights, size, circulation, and so forth, are more easily quantified and the common percentage of increased fee charged by most photographers is listed in the Price Charts.

Value factors are calculated using a combination of objective and subjective elements. You add to the fee to cover a proportion of any unusual costs incurred producing the photograph such as extra equipment rental, foreign travel, and so forth. You would also add something for a photograph that is hard to find or that involved great risk. A unique photo would command even more.

Client factors influence prices in both directions. Your price may go down a bit because you may want to give a break to a good, repeat client (but never below what it costs to be in business; see chapter 2). Also; you'll be likely to offer a package price when a large number of pictures is purchased from you for one project. When the so-called volume discount comes into play is an individual call. Some photographers start with ten photos for a small percentage off, others don't begin a discount until twenty-five or fifty photos are used.

The client factors that push a price upward relate to the importance of the photo to the project and to the size of the media buy. It takes more fortitude to deal with these aspects of pricing; clients may not want to share the information ("What do you need to know that for... just tell me how much."), and photographers are often

• • • •

intimidated from pursuing the subject. Do you have enough gumption to persist? You have every right to ask.

How do you determine the importance of the photo to the project? There are many clues, such as prominence of use and how many other photos are being used. For instance, will the photos be used on the cover, or just inside? Will they be used in a consumer ad, or in a small brochure? What will the size relationship be between the photo(s) and the rest of the piece? Ask to see the layout.

Imagine that your photo is being used as a double-page spread in an ad for a national magazine. Imagine further that the entire copy is one line of 10 point type along the bottom of the spread. Now, that is a photo that has importance to the ad; it is the ad!

The media buy figures are very important to know. It helps if you can see the relationship between what the client pays to run their ad and what they are willing to pay you for the use of your photograph. How would it affect you to know that you are being offered $1,000 for the use of a photograph on which the client is paying $200,000 for the magazine display space to run the ad? It helps to be able to quote to the buyer that the price you are asking is actually only a small percentage of the total production costs and surely an even smaller portion of the total media buy.

Perspective

Go to the library and look up the cost in *Standard Rate & Data* to advertise in the magazines your advertising clients deal with most often.

Similarly, when selling to an editorial or corporate client find out the circulation of the magazine, the number of copies of the book they are printing, or the level of distribution of a corporate brochure. You are seeking not just the numbers but their significance; their relationship to the total value of the overall production.

You say, "If I thought I was confused before...." Yes, it can be tough to figure out how much money to add for some of the value factors mentioned here. Not everything can be done with mathematical precision. Sometimes intuition, simply your gut feeling about the photograph and what it's worth, will influence the price.

To help you in this grey area, you might follow a method used by other photographers. Go down the list of factors and put a series of plus (+) marks in the right-hand column of your Stock Pricing Worksheet to represent the value, in each of the categories, that you perceive should be added to your photograph(s). Conversely, you might put some minus (-) signs when you choose to give a break to the client. A look at that visual summary of plus and minuses should help clarify your value of the photograph. It may also help you decide where you should be in the low-high range of our Price Charts. This worksheet will help bring you to the right price range, so you can determine your asking fee as well as calculate your bottom line figure. Most important of all, when you talk to the client, your reasons for charging a certain price should then be absolutely clear in your mind. When negotiating, you'll have, in front of you, all the aspects of the particular photograph that make it valuable, and you can use them to discuss it more clearly with a client if they balk at your price. Use a worksheet for each different photograph or group of photos, because they may have different relative values.

About the Price Charts

Prices were gathered from a wide range of professional photographers and stock photo agents. For each category there is a low-mid-high price as well as a section for commonly requested additional usages that will affect your price. To the right of the prices are blank spaces for each usage where you can keep track of the fees you are charging in each category.

Now, turn to the Price Charts, but know that you do yourself a grave disservice if you haven't prepared to negotiate. Pleasant, firm, informed negotiating is what will make these prices most useful.

Stock Pricing Worksheet

Photo Description (Story/set) ❏ Domestic ❏ Foreign

Client Name _____

Telephone _____

USAGE

Base price	Low	Medium	High
Type: Editorial			
Advertising			
Corporate			
Other			

Rights needed _____

Size/placement _____

Circulation/Print Run _____

Insertions (ad) _____

Distribution: ❏ Local ❏ Regional ❏ National

CD Rom _____

VALUE ADDED

Normal costs (in base price) _____

Extra costs:

 Released photo/model fees paid _____

 Released photo/property fees paid _____

Travel Costs _____

Extra equipment/rentals _____

Extraordinary costs _____
<div style="text-align:right">(helicopter, plane, balloon rental, etc.)</div>

High-risk _____

Extra Insurance _____

Unique (unable to be repeated) _____

Uncommon (not easily found) _____

Fresh (new material, never published) _____

CLIENT FACTORS

Importance of photo to Project (+) | Valued/repeat client (–)

Client status/media buy (+) | Volume photos used (–)

 Your first price _____

 Client offer _____

Final price billed _____

• • • •

Chapter 8

Introduction to the Price Charts

T he prices on the charts reflect those of professional photographers. In the case of stock, the prices shown indicate Reproduction Fees for the uses specified by photographers and stock photo agencies. For assignments, the prices exhibit Creative Fees for those basic usage categories.

Cautions About Terms

Before trying to use the Price Charts and, indeed, before entering into a negotiation, you need to understand some terms that are commonly used in the industry.

Care must be exercised when quoting usage rights terms because definitions do not have across-the-board acceptance throughout the trade. You could find that you and your clients have been using the same word, but assuming vastly different things! You must clarify everything; *always* ask your client what they mean, especially if they are talking about "all rights," "buy-outs," or "unlimited rights."

To clarify these terms, and to help reinforce the concept that you are partially basing your price on usage rights, always specify on your confirmation letters, delivery memos, and invoices what the usage rights parameters are.

Rights Terms

Because there are no universally accepted definitions of terms we are including, in part, those from the ASMP in an attempt to help broaden their acceptance in the absence of any other definitions. (Note: statements in brackets [] are authors comments.)

All rights: it can mean either (1) the buy-out of all rights including copyright or (2) the picking up of all rights except copyright by the client only for a certain use or a limited time or territory. [Because the meanings are sometimes used interchangeably, it is important that the contract, invoice, or purchase order specify whether the photographer is reserving any rights whatsoever. An All rights agreement is usually financially hazardous for the photographer who gives up all future right and title to their work, in exchange for a few dollars now.]

Buy-out: (1) Usually, a complete transfer of all rights in and to a work from the maker to the purchaser, including copyright. (2) Also, however, used to refer to the buying out of certain rights or all rights for a limited time or territory, etc. [As with All rights, any such agreement must be studied carefully to ascertain its exact scope. Buy-outs are as potentially hazardous to photographers as are All rights agreements.]

Distribution rights: a grant of rights to reproduce a photograph in a publication to be distributed in a certain geographic area(s). Not to be confused with translation rights. [Distribution rights, if specified, will dictate in what geographic area(s)—countries, states, etc.—the photo(s) may appear. Photographs that may appear in Spain, for instance, are not to be published in any other

Spanish speaking area unless so granted (see Translation rights).]

Exclusive rights: Grant of sole nontransferable right(s) to reproduce a work, usually limited to a specific time period, geographic area, type of product use, and publication. The same rights may not be granted to another party during the period or in the area of exclusivity. Fee reflects scope and duration agreed upon. [In other words, an exclusive agreement allows only that client, and no other, to use the work during a specified time or in a specified area.]

First rights: Rights to reproduce a photograph in one edition of one publication (or one program on an electronic medium) in any agreed territory prior to the publication of the same or essentially similar photograph in any other publication or program (or possibly competitive publication or program) in that area. Such rights are often granted subject to their being exercised within a specific period of time. Such rights also usually provide a specified period of time during which the photographer will not grant permission for publication of that work elsewhere (often from thirty to ninety days after publication). [In essence, the photographer is permitting their client to be the first to use the photograph(s), with the usual restrictions of time, area, etc. Because many photographs are time dated, especially news photographs, it is wise to place a restriction on their use—if the client doesn't publish the photograph(s) within a specified period (say, thirty days) first rights should revert back to the photographer who can then grant them to another client, since they were never exercised by the first client.]

Flat fee: Any fee that is offered as a single payment to cover licensing of use of a photograph regardless of size of reproduction, length of lease, geographical exposure, or extent of audience, and possibly including either reuse or even buy-out. [Another potentially hazardous arrangement for photographers if the fee is not high enough to cover all future potential use or if the grant of use is too broad or too vague.]

Grant of use (or Grant of rights): (see License of rights)

License of rights: Legal term for a grant of rights limited as to nature of rights, time, territory, etc. Ownership of the image remains with the photographer as licensor. [If you are involved in any license of rights activity it would be wise to first consult with your attorney or accountant to ascertain the sales tax rules that may apply in your state. Some states levy taxes against rights licensing while grants of use may not be subject to them.]

Multiple rights: Licensing of a photograph for use in more than one marketing area or form.

Nonexclusive rights: Grant of rights in a photograph by which the user does not have exclusive use of the photo(s) and therefore the photographer is not restricted from granting the same rights simultaneously to another user. (see Exclusive rights)

One-time rights: The right to reproduce a photograph once, in one single-language edition [Translation rights] of one publication (or one program in an electronic medium) in a specified agreed-upon area [Distribution rights]. [This is usually considered to be the most basic reproduction right that can be granted and is generally the basis for the pricing charts in this book.]

Outright sale: Transfer of ownership of a photograph, including all reproduction rights. Should be distinguished from a license, which is a specific grant of limited reproduction rights. [This should not be confused with the sale of a physical entity such as a print or transparency. Such a physical entity may be sold without also selling reproduction rights. The purchaser of such a physical entity may possess it, even destroy it (depending upon the sales agreement), but usually may not reproduce it, unless they have also obtained the reproduction rights. Portrait and wedding photographers have become very protective of their work; they may sell the physical entity, usually prints, but retain and guard the reproduction rights (the copyright).]

62

Translation rights: Specifies language of any text or other words that accompany the picture; should be distinguished from distribution rights. Fee offered will usually reflect the number of languages involved. [Do not confuse with distribution rights; granting the right to publish your photograph(s) in a Spanish publication, for instance, does not mean you have granted the right for them to be distributed in Spain, or Mexico, for that matter. Always specify a geographical area of distribution and a language if it will be in addition to, or other than, English.]

Unlimited use: Agreement that client may use specified rights in a photograph in any way it sees fit. [Obviously this grant of rights is not in the long-range best interests of photographers unless you are paid extremely well for it. And, if the client wants it this badly, you should reconsider its value to you in the future. What is it that they know, and you don't?]

World rights: Commonly used term that is subject to various interpretations according to industry and individual buyers but which basically allows for worldwide distribution of the product using the stock photo. It is essential, when pricing world rights, to reach an exact interpretation with the client. [See Distribution rights and Translation rights.]

Terms on the Pricing Charts

Various terms found on the pricing grids you should know:

Advertorial: a magazine or newspaper insert that is editorial in look, but is clearly advertising. Clients will wish to pay closer to editorial rates but don't forget, the intent is really advertising. You might be able to negotiate credit lines for yourself to compensate somewhat for the lower rates clients will want to offer.

Annual report: loosely divided in the charts by the size of the company. It is difficult to find any other natural divisions, but it can be important because smaller companies, usually having smaller budgets, generally pay less. Annual reports are usually produced by graphic design firms, but they may also be done by in-house communications employees.

Avg: means average price

Calendar: Single Hanger: means one photograph for the entire calendar,

Multi-sheet: 12 photographs—one per month, or 52 photographs—one per week

CD-ROM: is an acronym for "compact disk-read only memory," which means it is a compact disk, much like the ones you have for music, but used in a computer instead. These, however, also contain photography, sometimes in great amounts. They can be used by publishers as a substitute for printed publications and by corporations and possibly ad agencies for various other reasons. CD-ROMs are rapidly evolving and we will see many new ideas hit the horizon in the next few years. Because they are so new, some developers will try to convince photographers that the risks are high and they may not achieve the success they hope for, all as a justification for paying exceedingly low rates. Be forewarned, if so approached, why not then also ask for royalties in exchange for the low rate up front? If successful, you too, profit along with the developer or publisher while helping them out during the developmental stages with your lower initial rate. Another great danger is the ease with which images can be copied from a CD and used anywhere, and by anyone. As of yet there are no practical methods to prevent this; your best protection remains contractual language which deals with who may copy these images and how they may be used. (also see Interactive.)

63

Dummy magazine: a test magazine for advertiser, publisher, and reader evaluation.

Free-standing insert: a magazine or newspaper supplement, without editorial content, intended solely for advertising.

House publication: generally a promotional effort by a corporation to support products, employees, perhaps even the policies of the company. If it is internal, it is intended only for employees; external house publications usually carry a "heavier" promotional image that is for persons outside the corporate structure, like customers, distributors, users, and so forth.

Insertions: the number of times your photograph, usually in an advertisement or public relations effort, is placed within a publication(s). The number of times affects pricing and should be clearly expressed in a statement defining usage rights on invoices and assignment confirmations. Note: frequently your client will have no way of predetermining the number of insertions. Instead, photographers may allow their client to use image(s) for a specified period of time, frequently up to one year for advertising, for instance.

Interactive: a type of computer program that usually controls a CD-ROM disk drive, allowing a user to manipulate the outcome and direction of the program. Some times compact disks are inaccurately called "interactive CD's," although many of them are not.

Min: a minimum price

NA: not applicable

Negotiable or Neg: means a rate is to be negotiated and that those reporting on the survey don't have a set price

Photomatics: still photographs used on film or video tape to simulate motion; usually done to test advertising before committing to the high costs of filming or taping. Also done in theatrical releases, especially as title backgrounds.

Point of Purchase: photograph(s) used in part of a display to sell a product or service.

Specifying Reproduction Rights

There is no one right way to describe the reproduction rights you are granting but you will find that, with time, you begin to create your own standard. If you are unsure how, talk to other photographers, join a professional photographer's society and read their publications and attend business seminars aimed at photographers. Also, see the Bibliography for books providing information about photographic business practices. Also review chapter 6, "Writing a Usage Rights Statement."

The Price Charts—Assignments

The assignment price chart pages are divided alphabetically into the rather broad and commonly accepted categories of advertising, corporate, and editorial photography. Along the left side of each page are subcategories reflecting assignment usage, also listed alphabetically. Generally, throughout the middle of the page, you will find prices listed as low-middle-high. The prices shown were obtained from professional photographers and reflect experience and skill levels, geographical location, client size, and many of the other factors shown in the box, "Pricing Factors," in chapter 2. Off to the right of the price chart pages are blank lines where you can pencil in rates you have either received or calculated for yourself. Along the bottom of the page are commonly requested additional usages that will affect your final price.

The Price Charts—Stock

The stock price pages are laid out similarly to those for assignments.

The only general area of difference is that high-medium-low is shown in a vertical layout, as opposed to the horizontal arrangement for assignments. The low category is on top, the high price is on the bottom.

Pricing Based on the Space Rate

Never forget, these charts can be seductive. It will be a temptation to use them directly to determine your price, but don't succumb. They should only be used as a guide. Always first calculate the price you think you should charge, and then, and only then, consult the Price Charts to see how you compare.

But what if, even though you have faithfully followed each step as outlined, you are still unsure?

Many successful photographers price advertising photography based on the space rate/media buy method. To do so, first determine a percentage that seems appropriate and multiply it against the advertising page space rate for the publication where your work will appear. For example, say that the space rate (the page rate advertisers pay) in a publication is $50,000/page, and you have determined that 10% is the amount you will use. Your basis will then be $5,000 for a Creative Fee, to be adjusted by the other Pricing Factors that may apply.

Note: you may have to use a percentage based on a sliding scale. Advertisers may not be willing to pay the same percentage for an extremely high space rate as they would lower rates. For instance, 10% of $50,000/page would be $5,000 but 10% of $500,000 ($50,000) would probably be a higher rate than most advertisers would be willing to pay for photography. Why not start your percentage scale at 10% at the low end, say for any space rate below $50,000/page, and slide it down to 5% for any space rate above $200,000/page.

Although the space rate method may not work easily for editorial or corporate photography, at least let the rate the publication (where your photography will appear) charges for space, influence what you charge for editorial work in the publication.

Pricing Factors

As you learned in Chapter 2, Pricing Factors are elements that affect your base price (shown in the Charts as the one-time only, nonexclusive price). These factors are the more commonly requested additional usage rights and are treated by adding the value you place on them to the one-time only, nonexclusive price you first calculate. For ease of use, they have been listed as percentages and are shown directly on the Pricing Charts.

If the Charts show a one-time only price of $1,000, to add 75% the total would be $1,750, to add 100% the total would be $2,000, while to deduct 50% you end up with a figure of $500.

NOTE: these additional usages do not, of course, constitute all of the Pricing Factors that will affect the value of your stock or assignment photography. They are just some of the more commonly requested usages.

Placing a value on additional rights requests

When quoting fees for additional rights, like world rights, exclusive rights, or perhaps Spanish language (translation) rights, photographers use either a fixed percentage or a dollar amount. The fixed percentage they use is frequently based on a percentage of the Creative Fee (for assignments) or the Reproduction (stock) Fee, but a fixed dollar amount doesn't work in your best interest since it doesn't reflect all pricing factors.

Although a standard percentage or dollar amount may seem to simplify matters when determining fees, such fixed amounts just don't make good sense. For example, suppose you charge $500 for an editorial usage, and $3,000 for advertising. Is it really a wise policy to charge these two clients the same percentage of the original fee for, let's say, exclusive use of the photo? What if your standard policy on exclusivity is to charge 200% of the original total fee (Creative or Reproduction). Does it really make sense to charge the

editorial client only $500 for exclusive use while the advertising client pays $3,000 additional? Shouldn't the editorial client expect to pay more? After all, their request will also remove an image from the marketplace; it is possible you could have made more than the additional $500 (for exclusivity) had the photograph remained in your files and available for use by others.

A much better approach (for the rights shown on the Charts) would be to first establish a minimum rate, and then charge either the minimum or a percentage of the original total fee, whichever is higher. Therefore, if you are charging a client a low price (perhaps because it is an editorial or minor usage) and yet they need exclusivity, you risk losing less potential income. In the cases listed above you might have established a $1,500 minimum, and/or a double charge for exclusivity. The editorial client would therefore pay $2,000 total, $500 for the normal use, and $1,500 for the exclusivity request, while the advertiser would pay $6,000 total, $3,000 for a normal fee, and another $3,000 (200%) for exclusivity.

Miscellaneous Notes About the Charts

Assume the rates in the charts are based on one time, non-exclusive use, distribution in the US only, English language only. If it is different it will be noted in the upper left of each page.

A blank line on the charts means insufficient data was received. The category, without any data, is still included for your future use.

On the Assignment Price Charts, all the Digital Imaging fees are in addition to those for regular photography. In other words, if you are pricing a digital imaging assignment, which also includes original photography by you, add the digital imaging price to that for photography.

Warning!

If you use the charts as your sole method for pricing you will do yourself a major disservice. Just as detrimental would be to use them in an attempt to undercut what others charge in hopes of securing work. In the past, too many photographers have looked at surveys and made sure their prices were always lower than those in the survey. The end result has been that photographer's rates have not risen over the past years. Further depressing rates, photographer's have too often assumed an attitude of, "If I don't lower my prices, someone else will." Combine the negative things photographers do to themselves, with the general cost-cutting attitude of business and it is no wonder that photographers are in a downward spiral. Photographers have made it happen. What else can you expect when photographers tell buyers "This is my price, but it's negotiable", or "I can do it, what's your budget?" If you are always willing to bend, to ask only for what buyers are willing to offer, then photographer's rates will never move upward. When the buyer's budget is formulated the next year, and you continue to show willingness to work with ever lower rates, buyers feel safe in cutting the following year's budget, and the next, and the next...

Chapter 9

Assignment and Stock Photography Price Charts

The Price Charts in this chapter are only a framework. They provide a range from which to compare and to negotiate, based on your level of expertise, reputation, geographical area, and the market, usage, and client.

Remember, prices are not carved in stone.

Assignment Prices

Photographers have always had to be concerned about ensuring that they are compensated for their time. Your time has value. Accordingly, you will be charging, in part, for your creative time and for "other" time spent on behalf of your clients. For the following, you could either charge a flat rate or charge a percentage of the Creative Fee, calculated by dividing the Creative Fee by the number of assignment/shoot days. Your charges would be based on those "days."

WARNING: a Creative Fee "day" is NOT a "day rate!"

Pre- & Post-Production Time:
The fees in the pricing charts assume a full day of photography, and include a reasonable amount of time for pre-production: checking equipment, a few phone calls, etc., and a reasonable amount of time for post-production: editing film, preparing for shipping, checking and cleaning equipment, and so on. At what point do photographers begin to charge an additional amount for pre and/or post production time and how much do they charge?

Pre-production: Most said they always charge for it once it goes over 4 hours, and all said they charge for it once it becomes more than 8 hours. The amount ranged from $60/hour to $125/hour, with most reporting 50% of the Creative Fee "day."

Post-production: Similarly, like pre-production charges, once the time went over 4 hours photographers began to charge, from a minimum of $60/hour to $125/hour with most charging 50% of the Creative Fee "day."

Casting:
photographers usually charge for casting if their time is involved, whether or not, they have also hired a casting director. Some reported charging flat rates of $75/hour, or $350/half day, or $750/day, and again most reported a rate of 50% of the Creative Fee for their time.

Travel Time:
Because travel time assumes going beyond your home base area almost all photographers reported charging for it. Some reported not charging or would charge less if they could travel at times convenient to

MY FEE
$
$
$
$

• • • •

them or if they could go earlier or return later so that they could also take stock photographs or show potential clients their portfolio. The charges reported were usually 50% of the Creative Fee "day" for every day of travel.

$ []

Weather Days:

Most photographers were willing to wait one day for weather but then they began to charge after that. The fees levied generally ranged around 50% of a Creative Fee shoot "day" for each weather day. If on location, or for larger productions, the more inclined photographers were to charge and the more they had to charge to make up for their inability to do other work for other clients during this waiting period.

$ []

Half Days:

Traditionally a half day was considered to be any work taking less than 3 hours with the photographer always charging a premium price (frequently 2/3 of a "day rate") for that time. However, times are now different. Not one photographer reported doing half-days and the comments emphatically ranged from "No" or "Never" to "Never-nothing in this business takes a half day!" When you figure pre and post production time, even just for editing and the shipping of film, this determination to not do half-days seems to be good advice.

$ []

Commonly requested rights:

- Reuse after 1 year: the lowest rate reported was 75% of the normal Fee.

- Exclusive up to 1 year: photographers frequently include exclusivity for advertising accounts, and it must be accounted for in the Fee charged; others users, upon request, should expect to pay at least 200+% over the normal Fee.

- Unlimited up to 1 year: no photographer surveyed felt that this request should be allowed for less than 275+% of the normal Fee. However, the majority said that they wouldn't do it for any amount. If you decide to consider it, establish a sufficient minimum and charge a percentage, as detailed above.

- Buyout/All Rights: the lowest amount reported was 500+% over the normal Fee, however few photographers felt they would consider it for any amount. Remember, the money may seem good at first, but if a client is willing to pay this amount, shouldn't you be considering what the potential earnings of the image(s) could be if you retained ownership?

ASSIGNMENT PRICES – ADVERTISING

Base Fee: one year, exclusive	Low	Medium	High	Digital Imaging	
NATIONAL					
Advertorial	$ 2500	$ 3500	$ 6000	$ 2200	$ _____
Billboard, kiosk, transit display	2500	3500	6000	4500	_____
Catalog:					
numerous setups/photos per day	2500	3000	8000		_____
per setup	800	1100	5000		_____
Free-standing inserts	2100	3000	5000	3500-5000	_____
Magazine (consumer):					
single page	2500	3200	8000	4000	_____
spread	4000	5500	10,000	6000	_____
cover (back/inside)	5000	7500	15,000	10,000+	_____
Newspaper	1800	2800	6000	2800	_____
Packaging	2500	3500	5000	4400	_____
Point of purchase	2500	3100	5000	4000	_____
Television:					
photomatics	1800	2500	3500		_____
stills for commercials	2400	3300	5000		_____
publicity stills	1200	2200	5000		_____

Additional Usage		Add to Original Fee	
Insertions:	1 to 3 additional	38 %	_____ %
	4 to 10 additional	75 %	_____ %
	more than 10	150 %	_____ %
Rights:	Reuse after 1 year	(depends upon usage)	
	Exclusive	(depends upon usage)	
	Unlimited	(depends upon usage)	
	Buyout/All Rights	(depends upon usage)	

ASSIGNMENT PRICES – ADVERTISING

Base Fee: one year, exclusive	Low	Medium	High	Digital Imaging	
LOCAL					
Advertorial	$ 2200	$ 2800	$ 5000	$ 1000 min	$
Billboard, kiosk, transit display	2000	2700	5000	2000	
Catalog:					
numerous setups/photos per day	1750	2500	5000		
per setup		600	900	3000	
Free-standing inserts	1400	2200	3500	2000-3000	
Magazine:					
single page	2500	3500	5000	2000	
spread	2900	3800	7500	3200	
cover (back/inside)	3000	3800	10,000		
Newspaper	1700	2250	4000	1700	
Packaging	1800	2500	3500	3200	
Point of purchase	1700	2550	4000	2800	
Television:					
photomatics	1800	2200	3500		
stills for commercials	1900	2400	3500		
publicity stills	1700	2200	3000		

Additional Usage	Add to Original Fee	
Insertions: 1 to 3 additional	38 %	%
4 to 10 additional	70 %	%
more than 10	140 %	%

Rights: Reuse after 1 year (depends upon usage)
Exclusive (depends upon usage)
Unlimited (depends upon usage)
Buyout/All Rights (depends upon usage)

• • • • •

ASSIGNMENT PRICES – ADVERTISING

Base Fee: one year, exclusive	Low	Medium	High	Digital Imaging	
TRADE					
Catalog:					
numerous setups/photos per day	$ 1800	$ 2300	$ 6000		$ _____
per setup		500	750	4000	_____
Free-standing inserts	1700	2300	3500	2000-3000	_____
Magazine:					
single page	2400	2800	6000	2800	_____
spread	3100	3700	9000	4000	_____
cover (back/inside)	3100	4300	12,000		_____
Newspaper	2350	2500	5000	1800	_____
Packaging	1500	2000	3500	3200	_____

Additional Usage	Add to Original Fee	
Insertions: 1 to 3 additional	50 %	_____ %
4 to 10 additional	100 %	_____ %
more than 10	150 %	_____ %

Rights:	Reuse after 1 year	(depends upon usage)
	Exclusive	(depends upon usage)
	Unlimited	(depends upon usage)
	Buyout/All Rights	(depends upon usage)

• • • •

ASSIGNMENT PRICES – CORPORATE

Base Fee: one year, exclusive	Low	Medium	High	Digital Imaging	
Annual report:					
major multinational company	$ 2500	$ 3500	$ 8000	$ 5500	$ ☐
national company	1700	2000	7500	2500	☐
small or local company	1500	1800	3500	1000	☐
Brochures	1500	2000	3500	2200	☐
CD-ROM: used as product, not source of photo clip art	2000	2500	3500		☐
House publications:					
internal: for employees, not as general public relations	1250	1600	3500	1000 min	☐
external: for use as public relations possibly advertising	1800	2100	7000	1600-3000	☐
internal/external: for employees and as promotion	1800	2400	7000	2000-3500	☐
Public relations	1000	1300	7000	1800	☐
Presentation:					
prints: display in lobbies, trade shows, etc	1750	2100	3500	2500-3800	☐
slide show: in-house for employees, sales staff, etc	1100	1400	3500	1000 min	☐
trade: public relations, advertising, etc	1800	2200	7000	2000-3500	☐
video: part of a larger video tape production	1800	2400	7000	1000 min	☐

Additional Usage

Rights:	Reuse after 1 year	(depends upon usage)
	Exclusive	(depends upon usage)
	Unlimited	(depends upon usage)
	Buyout/All Rights	(depends upon usage)

ASSIGNMENT PRICES – EDITORAL

Base Fee: one time, non-exclusive	Low	Medium	High	Digital Imaging	
Books:					
consumer (trade)–picture, general	$ 500	$ 750	$ 1000		$ ☐
textbooks, encyclopedia	500	750	1200		☐
CD-ROM (interactive or not)	450	500	1000		☐
Magazines:					
news and general feature	450	800	1500	1000	☐
specialty magazines	450	550	1500	1000	☐
corporate/house publications					
(not used for advertising or public relations)	750	1000	1500	2200 avg	☐
Newspapers:					
Dailys	400	500	600		☐
Sunday Supplements/magazines	500	600	800		☐

Additional Usage

Rights:	Reuse after 1 year	(depends upon usage)
	Exclusive	(depends upon usage)
	Unlimited	(depends upon usage)
	Buyout/All Rights	(depends upon usage)

STOCK PRICES – ADVERTISING

ADVERTORIAL

Base Fee: one time, non-exclusive *	¼ Page	½ Page	Full Page	Back Cover	¼ Page	½ Page	Full Page	Back Cover
Circulation								
	$ 500	$ 625	$ 800	$ 1275				
less than 100,000	550	650	900	1350	$	$	$	$
	600	675	1000	1475				
	600	700	1100	1500				
100,000 - 500,000	650	750	1150	1700				
	675	775	1275	1900				
	700	800	1325	2100				
500,000 - 1,000,000	725	850	1400	2200				
	740	875	1500	2300				
	750	900	1500	2300				
1,000,000 - 3,000,000	825	1050	1800	2500				
	1000	1200	1900	2800				
	1150	1300	2050	3200				
more than 3,000,000	1225	1475	2175	3500				
	1375	1600	2250	3800				

Additional Usage		Add to Original Fee	
Insertions:	1 to 3 additional	25 %	%
	4 to 10 additional	50 %	%
	more than 10	75 %	%
Rights:	Reuse after 1 year	(depends upon usage)	
	Exclusive	(depends upon usage)	
	Unlimited	(depends upon usage)	
	Buyout/All Rights	(depends upon usage)	

*** Contrary to other types of advertising, advertorials usually appear only in one issue of one magazine**

STOCK PRICES – ADVERTISING

BILLBOARDS

Base Fee: one time, non-exclusive	up to 6 months	up to 1 year	up to 6 months	up to 1 year
Distribution – locations				
	$ 1500	$ 2500		
Local – city or less than 10	1750	2750	$ []	$ []
	2000	3000		
	2000	3000		
Regional – up to 100	3000	4000	[]	[]
	5000	6000		
	3500	5000		
National – over 100	5000	6500	[]	[]
	7000	8500		

Additional Usage

Rights:	Reuse after 1 year	(depends upon usage)
	Exclusive	(depends upon usage)
	Unlimited	(depends upon usage)
	Buyout/All Rights	(depends upon usage)

STOCK PRICES – ADVERTISING

BROCHURES/CATALOGS

Base Fee: one time, non-exclusive	¼ Page	½ Page	Full Page	Cover	¼ Page	½ Page	Full Page	Cover
Press Run								
	$ 500	$ 550	$ 700	$ 1250				
less than 25,000	525	600	750	1500	$	$	$	$
	575	650	1000	1600				
	575	700	800	1650				
25,000 - 50,000	650	800	1000	1775				
	700	950	1250	1900				
	700	850	1450	2000				
50,000 - 100,000	850	1000	1550	2500				
	1000	1200	1700	2600				
	850	1150	1400	2700				
100,000 - 500,000	1000	1300	1800	3200				
	1100	1500	2000	3400				
	1200	1400	2200	3500				
more than 500,000	1450	1750	2500	4000				
	1600	2000	3000	5000				

Additional Usage **Add to or Deduct from Original Fee**

Double page (additional % of full page fee)	75 %
Back cover (less % of cover fee)	25 %
Wrap-around cover (additional % of cover fee)	75 %

Rights:
Reuse after 1 year (depends upon usage)
Exclusive (depends upon usage)
Unlimited (depends upon usage)
Buyout/All Rights (depends upon usage)

%
%
%

STOCK PRICES – ADVERTISING

CALENDAR (usually given away for promotion of product or service. Also see Calendar in Corporate and Miscellaneous sections)

Base Fee: one time, non-exclusive	Insert Photo	Main Photo	Insert Photo	Main Photo
Distribution	(per photo)	(per photo)		
Single Hanger				
	$ 800	$ 1200		
less than 50,000	1000	1800	$ ____	$ ____
	1200	2300		
	1500	2200		
more than 50,000	1750	2500	____	____
	2000	3000		
Multi-sheet				
12 months				
	600	950		
less than 50,000	700	1200	____	____
	800	1700		
	800	1800		
more than 50,000	900	2000	____	____
	1000	2200		
52 weeks				
	500	600		
less than 50,000	550	650	____	____
	600	700		
	600	800		
more than 50,000	650	900	____	____
	700	1000		

Additional Usage

Rights:	Reuse after 1 year	(depends upon usage)
	Exclusive	(depends upon usage)
	Unlimited	(depends upon usage)
	Buyout/All Rights	(depends upon usage)

STOCK PRICES – ADVERTISING

MAGAZINES – CONSUMER LOCAL

Base Fee: one insertion, one publication	¼ Page	½ Page	Full Page	Back Cover	¼ Page	½ Page	Full Page	Back Cover
Distribution								
	$ 650	$ 900	$ 1000	$ 3000				
less than 100,000	775	950	1450	3500	$	$	$	$
	850	1100	1500	4000				
	900	1000	1500	3500				
100,000 - 250,000	950	1100	1850	4000				
	1000	1275	2000	5000				
	1050	1200	1750	5750				
250,000 - 500,000	1100	1300	2200	6000				
	1150	1400	2500	6500				
	1100	1300	2050	6000				
more than 500,000	1200	1450	2500	6500				
	1300	1600	3000	7000				

Additional Usage	Add to Original Fee	
Insertions: 1 to 3 additional	25 %	%
4 to 10 additional	50 %	%
more than 10	negotiable	%
Rights: Reuse after 1 year	(depends upon usage)	
Exclusive	(depends upon usage)	
Unlimited	(depends upon usage)	
Buyout/All Rights	(depends upon usage)	

79

STOCK PRICES – ADVERTISING

MAGAZINES – CONSUMER REGIONAL

Base Fee: one insertion, one publication	¼ Page	½ Page	Full Page	Back Cover	¼ Page	½ Page	Full Page	Back Cover
Distribution								
	$ 650	$ 1000	$ 1600	$ 4000				
less than 250,000	875	1200	1800	5000	$	$	$	$
	1000	1275	2000	5000				
	1100	1325	2150	6000				
250,000 - 500,000	1200	1400	2300	7000				
	1300	1500	2400	8000				
	1200	1475	2300	7000				
500,000 - 1,000,000	1300	1550	2500	8000				
	1400	1700	2600	9000				
	1400	1650	2525	8000				
more than 1,000,000	1450	2000	2800	9000				
	1500	2500	3000	10,000				

Additional Usage		Add to Original Fee	
Insertions:	1 to 3 additional	25 %	%
	4 to 10 additional	50 %	%
	more than 10	75 %	%
Rights:	Reuse after 1 year	(depends upon usage)	
	Exclusive	(depends upon usage)	
	Unlimited	(depends upon usage)	
	Buyout/All Rights	(depends upon usage)	

80

STOCK PRICES - ADVERTISING

MAGAZINES-CONSUMER NATIONAL

Base Fee: one insertion, one publication	¼ **Page**	½ **Page**	**Full Page**	**Back Cover**	¼ **Page**	½ **Page**	**Full Page**	**Back Cover**
Distribution								
	$ 1000	$ 1300	$ 2100	$ 6000				
less than 500,000	1100	1400	2300	6500	$	$	$	$
	1200	1600	2500	7000				
	1200	1475	2300	7000				
500,000 - 1,000,000	1400	1700	2550	8000				
	1600	1900	3000	9000				
	1500	1800	2800	8000				
1,000,000 - 3,000,000	2000	2350	3150	9000				
	2400	2600	3700	10,000				
	2500	2800	3600	10,000				
more than 3,000,000	2700	3750	5100	12,000				
	3000	4500	6000	15,000				

Additional Usage		**Add to Original Fee**	
Insertions:	1 to 3 additional	25 %	☐ %
	4 to 10 additional	50 %	☐ %
	more than 10	75 %	☐ %
Rights:	Reuse after 1 year	(depends upon usage)	
	Exclusive	(depends upon usage)	
	Unlimited	(depends upon usage)	
	Buyout/All Rights	(depends upon usage)	

STOCK PRICES – ADVERTISING

MAGAZINES – TRADE

Base Fee: one insertion, one publication	¼ Page	½ Page	Full Page	Back Cover		¼ Page	½ Page	Full Page	Back Cover
Distribution									
less than 250,000	$ 750	$ 1800	$ 2500	$ 2500		$ []	$ []	$ []	$ []
	875	1825	2600	3000					
	900	1950	2675	3500					
250,000 - 500,000	950	2000	2800	3000		[]	[]	[]	[]
	1050	2100	2950	4000					
	1150	2150	3175	5000					
500,000 - 1,000,000	1250	2200	3150	5000		[]	[]	[]	[]
	1300	2250	3275	5500					
	1400	2350	3350	6000					
more than 1,000,000	1500	1750	3375	6000		[]	[]	[]	[]
	1600	2200	3500	7000					
	1700	2400	3600	8000					

Additional Usage		Add to Original Fee	
Insertions:	1 to 3 additional	25 %	[] %
	4 to 10 additional	50 %	[] %
	more than 10	75 %	[] %
Rights:	Reuse after 1 year	(depends upon usage)	
	Exclusive	(depends upon usage)	
	Unlimited	(depends upon usage)	
	Buyout/All Rights	(depends upon usage)	

STOCK PRICES – ADVERTISING

MISCELLANEOUS

Base Fee: one time, non-exclusive	Flat Fee $	% of Normal Fee (*1)	Flat Fee $	% of Normal Fee (*1)
Artists Reference (*2)		$ 50 75 100	$ ___	$ ___
Art Rendering (*3)		50 75 100	___	___
Presentation/Layout (*4)	250 300 400		___	___

Additional Usage

None apply – usage for the above are one time only

(*1) % of the normal Fee you would have charged had your photograph been used for the job instead of art work

(*2) use of a photograph, by an artist, for technical and/or detail reference. The resultant artwork will not be so complete as to render the photograph as recognizable within the artwork. See category of use where advertising will appear and charge a percentage.

(*3) use of a photograph, by an artist, to produce a recognizable rendition. The fee charged may be a percentage of the normal fee as if the photograph had been used in the advertising. See category of use where advertising will appear and charge a percentage.

(*4) use of a photograph, by an ad agency, for presentation to a client for approval. Reproduction rights, beyond this use, are not granted. If photograph is used in final advertising see appropriate category for usage fee.

STOCK PRICES – ADVERTISING

NEWSPAPERS

Base Fee: one time, non-exclusive	¼ Page	½ Page	Full Page	¼ Page	½ Page	Full Page
Circulation						
	$ 450	$ 900	$ 1400			
less than 250,000	650	1000	1450	$ _____	$ _____	$ _____
	700	1150	1750			
	700	1100	1800			
250,000 - 500,000	800	1200	2900	_____	_____	_____
	900	1300	3100			
	950	1350	3200			
more than 500,000	1000	1400	3500	_____	_____	_____
	1200	1575	4000			

Additional Usage		Add to Original Fee	
Insertions:	1 additional	25 %	_____ %
	2 to 7 additional	75 %	_____ %
	8 to 28 additional	100 %	_____ %
	more than 28	negotiable	_____ %
Rights:	Reuse after 1 year	(depends upon usage)	
	Exclusive	(depends upon usage)	
	Unlimited	(depends upon usage)	
	Buyout/All Rights	(depends upon usage)	

STOCK PRICES – ADVERTISING

PACKAGING

Base Fee: one time, non-exclusive	Spot Use	Major Use	Overall Design	Spot Use	Major Use	Overall Design
Distribution						
	$ 600	$ 2000	$ 3000			
Local	800	2500	3500	$	$	$
	1000	3000	4000			
	1000	2500	3500			
Regional	1200	3100	4200			
	1800	3400	4400			
	1000	4000	5000			
National	1500	4500	6000			
	2000	5000	7000			
	600	1500	2500			
Test	800	2000	3000			
	1600	2400	3500			

Additional Usage

Rights:	Reuse after 1 year	(depends upon usage)
	Exclusive	(depends upon usage)
	Unlimited	(depends upon usage)
	Buyout/All Rights	(depends upon usage)

•••••

STOCK PRICES – ADVERTISING

POINT OF PURCHASE

Base Fee: one time, non-exclusive	Spot Use	Major Use	Overall Design		Spot Use	Major Use	Overall Design
Distribution/Press Run							
	$ 625	$ 900	$ 1100				
Local (Under 10,000)	725	1000	1200		$ []	$ []	$ []
	800	1300	1900				
	750	1400	2200				
Regional (10 - 25,000)	900	1500	2400		[]	[]	[]
	1250	1700	2900				
	1500	2000	2500				
National (Over 25,000)	1850	2350	3500		[]	[]	[]
	2000	3000	5000				

Additional Usage

Rights:	Reuse after 1 year	(depends upon usage)
	Exclusive	(depends upon usage)
	Unlimited	(depends upon usage)
	Buyout/All Rights	(depends upon usage)

STOCK PRICES – ADVERTISING

POSTERS (although they may be sold, the intent is to advertise a product or service)

Base Fee: one time, non-exclusive	US	World	US	World
Press Run: 16x20 or smaller				
less than 10,000	$ 1250 1325 1350	$ 1500 1800 2500	$ ▢	$ ▢
10,000 - 50,000	1400 1475 1550	1600 2800 3200	▢	▢
more than 50,000	1575 1750 1900	2000 3200 4500	▢	▢
Press Run: Larger than 16x20				
less than 10,000	1425 1500 1600	1900 2500 2700	▢	▢
10,000 - 50,000	1650 1800 1950	1900 3100 3500	▢	▢
more than 50,000	2025 2100 2200	2600 3800 5000	▢	▢

Additional Usage

Rights:	Reuse after 1 year	(depends upon usage)
	Exclusive	(depends upon usage)
	Unlimited	(depends upon usage)
	Buyout/All Rights	(depends upon usage)

● ● ● ● ●

STOCK PRICES – ADVERTISING

TELEVISION – COMMERCIALS

Base Fee: non-exclusive

Circulation	Local/Cable	Regional	National	Local/Cable	Regional	National
1 month	$ 550	$ 700	$ 800	$ ____	$ ____	$ ____
	600	750	900			
	650	850	1000			
1 cycle / 13 weeks	660	900	1100	____	____	____
	750	1000	1200			
	850	1150	1300			
2 cycles / 26 weeks	900	1100	1400	____	____	____
	1000	1200	1500			
	1100	1300	1700			
1 year / 52 weeks	1250	1300	2200	____	____	____
	1400	1500	2300			
	1500	1800	2400			

Additional Usage* **Add to Original Fee**

Public service announcement/commercial	____ %	____ %
Test: on-air	____ %	____ %
off-air	____ %	____ %

Rights: Reuse after 1 year (depends upon usage)
 Exclusive (depends upon usage)
 Unlimited (depends upon usage)
 Buyout/All Rights (depends upon usage)

***** None were reported although these are known to apply at times.**

STOCK PRICES – CORPORATE

ANNUAL REPORTS

Base Fee: one time, non-exclusive	¼ Page	½ Page	Full Page	Cover	¼ Page	½ Page	Full Page	Cover
Distribution								
	$ 450	$ 550	$ 800	$ 1250				
less than 50,000	500	600	900	1300	$	$	$	$
	600	750	1100	1600				
	600	800	1100	1800				
50,000 - 100,000	700	900	1300	2000				
	900	1000	1400	2400				
	950	950	1400	2500				
100,000 - 1,000,000	1000	1025	1500	2700				
	1150	1275	1700	2950				
	1000	1100	1650	2750				
more than 1,000,000	1150	1200	1800	3400				
	1200	1300	2000	3600				

Additional Usage	Add to or Deduct from Original Fee		
Double page (additional % of full page fee)	75 %		%
Back cover (less % of cover fee)	15 %		%
Wrap-around cover (additional % of cover fee)	50 %		%

Rights:	Reuse after 1 year	(depends upon usage)
	Exclusive	(depends upon usage)
	Unlimited	(depends upon usage)
	Buyout/All Rights	(depends upon usage)

● ● ● ● ●

STOCK PRICES – CORPORATE

AUDIO VISUAL (in-house use only)

Base Fee: one time, non-exclusive	1 Showing	1 Showing
Number of Images	(per photo)	(per photo)
1	$ 200	$
	250	
	300	
2 - 25	175	
	200	
	225	
25 - 100	125	
	150	
	175	
Over 100	75	
	100	
	125	

Additional Usage	Add to Original Fee	
Trade slide show (for promotion)	75 %	%
Showings: 2 - 10	40 %	%
more than 10	50 %	%
up to 1 year	70 %	%

Rights:

	Reuse after 1 year	(depends upon usage)
	Exclusive	(depends upon usage)
	Unlimited	(depends upon usage)
	Buyout/All Rights	(depends upon usage)

STOCK PRICES – CORPORATE

CALENDAR*

Base Fee: one time, non-exclusive	Insert Photo	Main Photo	Insert Photo	Main Photo
Distribution	(per photo)	(per photo)		
Single Hanger	$ 600	$ 1125		
less than 50,000	700	1725	$ ☐	$ ☐
	800	1900		
	800	2100		
more than 50,000	900	2600	☐	☐
	1000	2700		
Multi-sheet: 12 months				
	600	900		
less than 50,000	700	1250	☐	☐
	800	1550		
	700	1675		
more than 50,000	800	1750	☐	☐
	900	1900		
Multi-sheet: 52 weeks				
	400	700		
less than 50,000	500	750	☐	☐
	600	900		
	500	975		
more than 50,000	600	1100	☐	☐
	700	1250		

Additional Usage

Royalties: after a press run of 50,000 copies add the following cents per calendar: promotional $0.50 ☐
resale $0.75 ☐

Rights: Reuse after 1 year (depends upon usage) | Unlimited (depends upon usage)
Exclusive (depends upon usage) | Buyout/All Rights (depends upon usage)

* primary use is promotion; if sold, royalty fees may apply. Also see Posters in Advertising and Miscellaneous

STOCK PRICES – CORPORATE

HOUSE PUBLICATION – EXTERNAL (promotional / public relations)

Base Fee: one time, non-exclusive	¼ Page	½ Page	Full Page	Cover	¼ Page	½ Page	Full Page	Cover
Circulation								
	$ 350	$ 400	$ 550	$ 900				
less than 25,000	450	450	700	1100	$	$	$	$
	500	500	1000	1500				
	400	450	675	1100				
25,000 - 50,000	500	525	700	1300				
	600	550	800	1400				
	525	550	775	1200				
50,000 - 100,000	600	600	825	1400				
	700	800	950	1500				
	500	600	900	1300				
more than 100,000	800	1200	1275	1800				
	1200	1800	2000	3000				

Additional Usage	Add to or Deduct from Original Fee	
Double page (additional % of full page fee)	75 %	%
Back cover (less % of cover fee)	35 %	%
Wrap-around cover (additional % of cover fee)	50 %	%

Rights:

	Reuse after 1 year	(depends upon usage)
	Exclusive	(depends upon usage)
	Unlimited	(depends upon usage)
	Buyout/All Rights	(depends upon usage)

92

STOCK PRICES – CORPORATE

HOUSE PUBLICATION – INTERNAL (employees only)

Base Fee: one time, non-exclusive	¼ Page	½ Page	Full Page	Cover	¼ Page	½ Page	Full Page	Cover
Circulation								
	$ 250	$ 300	$ 375	$ 600				
less than 5,000	300	350	450	700	$	$	$	$
	350	400	600	800				
	275	325	450	700				
5,000 - 25,000	325	400	550	800				
	350	450	650	900				
	300	350	525	775				
25,000 - 50,000	325	450	600	850				
	400	525	675	950				
	350	400	600	1100				
50,000 - 100,000	350	500	650	1200				
	400	550	700	1400				
	375	425	625	1400				
more than 100,000	400	500	675	1800				
	500	600	725	2200				

Additional Usage	Add to or Deduct from Original Fee	
Double page (additional % of full page fee)	75 %	%
Back cover (less % of cover fee)	25 %	%
Wrap-around cover (additional % of cover fee)	50%	%

Rights:	Reuse after 1 year	(depends upon usage)
	Exclusive	(depends upon usage)
	Unlimited	(depends upon usage)
	Buyout/All Rights	(depends upon usage)

STOCK PRICES – CORPORATE

POSTERS*

Base Fee: one time, non-exclusive	US	World	US	World
Press Run: 16x20 or smaller				
	$ 975	$ 1100		
less than 10,000	1100	1300	$ ____	$ ____
	1150	1425		
	1200	1375		
10,000 - 50,000	1375	1500	____	____
	1500	1625		
	1425	1550		
more than 50,000	1500	1680	____	____
	1650	1875		
Press Run: Larger than 16x20				
	1050	1375		
less than 10,000	1225	1500	____	____
	1300	1625		
	1375	1550		
10,000 - 50,000	1425	1680	____	____
	1725	1875		
	1675	1800		
more than 50,000	1800	2000	____	____
	1925	2200		

Additional Usage

Royalties:** after a press run of 50,000 copies add the following cents per poster: promotional $0.50 ____

resale $0.75 ____

Rights: Reuse after 1 year (depends upon usage) | Unlimited (depends upon usage)
 Exclusive (depends upon usage) | Buyout/All Rights (depends upon usage)

* primary use is promotion; if sold, royalty fees may apply. Also see Posters in Advertising and Miscellaneous
** number reporting was too low for statistical accuracy

STOCK PRICES – CORPORATE

RECORDING – PROMOTIONAL*

Base Fee: one time, non-exclusive	Tapes/CD's/Laser Disk	1 Showing
	$ 575	$ [____]
Back cover	800	
	1200	
	700	
Front cover	1200	[____]
	1600	
	1000	
Wrap-around cover	1600	[____]
	2000	
	350	
Enclosures	600	[____]
	750	

Additional Usage	Add to or Deduct from Original Fee	
Tests	Deduct 35 %	[____] %
Usage on both tape and CD **	___ %	[____] %

Royalties:** after a press run of _____ copies add the following cents per unit: promotional $0.00 [____]

resale $0.00 [____]

Rights: Reuse after 1 year (depends upon usage)
Exclusive (depends upon usage)
Unlimited (depends upon usage)
Buyout/All Rights (depends upon usage)

*** primary use is promotion; if sold, royalty fees may apply. Also see Calendar in Advertising and Miscellaneous**

**** number reporting was too low for statistical accuracy**

STOCK PRICES – EDITORIAL

BOOKS – CONSUMER/TRADE

Base Fee: one time, non-exclusive	¼ Page	½ Page	Full Page	Cover	¼ Page	½ Page	Full Page	Cover
Hardcover, including Trade Books	$250	$ 275	$ 400	$ 1000	$ ☐	$ ☐	$ ☐	$ ☐
less than 40,000	275	325	450	1200				
	300	375	475	1700				
	275	325	450	1500				
more than 40,000	300	375	525	1700	☐	☐	☐	☐
	325	400	600	2000				
Picture Books	400	500	900	1200				
less than 40,000	500	600	1000	1500	☐	☐	☐	☐
	600	700	1100	1800				
	600	700	1000	1500				
more than 40,000	700	800	1100	2500	☐	☐	☐	☐
	800	900	1200	3000				
Paperback Books	225	275	350	800				
less than 40,000	275	325	450	900	☐	☐	☐	☐
	300	375	600	1000				
	275	300	500	1000				
more than 40,000	325	350	600	1200	☐	☐	☐	☐
	375	425	700	1300				

Additional Usage	Add to or Deduct from Original Fee			Add to Original Fee	
Author head shot	0 %	☐ %	Wrap-around cover	50 %	☐ %
Chapter openers	25 %	☐ %	Book Rights:		
Double page	75 %	☐ %	Distribute US edition abroad	50 %	☐ %
Dummy Books	Deduct 25 %	☐ %	One-time world rights: one language	100 %	☐ %
Revisions	75 %	☐ %	Each additional language	25 %	☐ %
Unit openers/frontispiece	25 %	☐ %	All languages	100 %	☐ %

• • • •

STOCK PRICES – EDITORIAL

BOOKS – EDUCATIONAL

Base Fee: one time, non-exclusive	¼ Page	½ Page	Full Page	Cover	¼ Page	½ Page	Full Page	Cover
Encyclopedia								
	$ 225	$ 275	$ 375	$ 800				
less than 40,000	275	350	425	1100	$ ____	$ ____	$ ____	$ ____
	300	400	500	1300				
	250	300	400	900				
more than 40,000	325	350	475	1200	____	____	____	____
	375	425	550	1400				
Textbooks								
	225	225	325	750				
less than 40,000	275	275	400	1100	____	____	____	____
	325	350	500	1300				
	225	250	350	900				
more than 40,000	300	325	550	1300	____	____	____	____
	350	375	625	1500				
Textbook Supplementary Materials								
				700				
Cassette/ CD Cover				850	____	____	____	____
				900				
Instructor's manual / Study Guide / Workbook*								
	75	175	200	700				
more than 40,000	100	225	250	800	____	____	____	____
	125	300	350	900				

Additional Usage

All variables are the same as for Consumer books see Page 96

Rights: Reuse after 1 year (depends upon usage)
 Exclusive (depends upon usage)
 Unlimited (depends upon usage)
 Buyout/All Rights (depends upon usage)

*** Fees shown apply if photos reused from textbooks; if new, or not free distribution, then price same as or no less than 75% of textbook fee**

97

● ● ● ● ●

STOCK PRICES – EDITORIAL

CD-ROM DISK (not for retail sale)

Base Fee: one time, non-exclusive

Number of Pressings	1-10 Images (per photo)	1-10 Images (per photo)
less than 10.000	$ 200	$ ☐
	250	
	300	
10,000 - 50,000	250	
	300	☐
	350	
more than 50,000	300	
	350	☐
	400	
Test pressing less than 1,000	200	
	250	☐
	300	

Additional Usage	**Add to or Deduct from Original Fee**	
Number of Images: 10 - 50	Deduct 10 %	☐ %
50 - 100	Deduct 20 %	☐ %
over 100	negotiable	☐ %

Royalties* after a press run of 10,000, add the following cents per disk: $0.05 ☐

Rights: Reuse after 1 year (depends upon usage)
Exclusive (depends upon usage)
Unlimited (depends upon usage)
Buyout/All Rights (depends upon usage)

WARNING: Since these photos are intended for education, and not reproduction, do NOT allow photographs to be saved on disk more than 72 dpi or larger than 3 1/2"x5" in size. NEVER enter into an agreement involving digital imaging UNTIL you fully understand the relationship between digital image resolution and image or file size.

*** number reporting was too low for statistical accuracy**

STOCK PRICES – EDITORIAL

DISPLAY PRINTS* (Public locations-business, stores)

Base Fee: one time, non-exclusive	Exhibit Fee	Exhibit Fee
Exhibit ** / Decorative Fine Prints		
	$ 500	
1	600	$ _____
	700	
	800	
2 - 4	900	_____
	1000	
	1000	
more than 5	1250	_____
	1500	
	1500	
Permanent exhibition (per print)	2000	_____
	2500	
	1200	
Traveling exhibition (1 year, per print)	1400	_____
	1600	

Additional Usage	Add to or Deduct from Original Fee	
Personal-home & office use	Deduct 25 %	_____ %
Print size: smaller than 16x20	Deduct 25 %	_____ %
larger than 16x20	50 %	_____ %

Rights: Reuse after 1 year (depends upon usage) | Unlimited (depends upon usage)

Exclusive (depends upon usage) | Buyout/All Rights (depends upon usage)

*** These prints are for exhibit only; if for retail sale see Miscellaneous**

**** Exhibit Fee assumes public is charged admission fee. If not, lower Fee by 10 – 15%**

STOCK PRICES – EDITORIAL

MAGAZINES – TRADE

Base Fee: one time, non-exclusive	¼ Page	½ Page	Full Page	Cover	¼ Page	½ Page	Full Page	Cover
Circulation								
	$ 200	$ 300	$ 500	$ 900				
less than 50,000	250	350	550	1100	$	$	$	$
	275	400	600	1200				
	250	350	550	1025				
50,000 - 100,000	300	400	575	1200				
	350	450	650	1500				
	300	350	700	1200				
100,000 - 250,000	350	400	775	2000				
	400	500	825	2500				
	350	450	750	2000				
250,000 - 500,000	400	525	850	2500				
	450	575	950	3000				
	400	525	850	3000				
more than 500,000	450	575	950	4000				
	500	650	1000	5000				

Additional Usage	**Add to or Deduct from Original Fee**	
Double page: (spread) (additional % of Full Page fee)	100 %	%
Back/Inside cover: (less % of Cover fee)	35 %	%

Rights: Reuse after 1 year (depends upon usage)
 Exclusive (depends upon usage)
 Unlimited (depends upon usage)
 Buyout/All Rights (depends upon usage)

STOCK PRICES – EDITORIAL

MAGAZINES – CONSUMER

Base Fee: one time, non-exclusive	¼ Page	½ Page	Full Page	Cover	¼ Page	½ Page	Full Page	Cover
Circulation								
	$ 250	$ 325	$ 600	$ 1000				
less than 100,000	275	400	625	1100	$	$	$	$
	325	450	675	1725				
	300	400	675	1525				
100,000 - 500,000	375	475	725	2000				
	400	525	825	2500				
	375	500	800	2500				
500,000 - 1,000,000	400	550	825	3000				
	450	650	925	3500				
	450	550	950	1875				
1,000,000 - 3,000,000	475	575	1025	1925				
	525	700	1100	4000				
	500	575	1025	2100				
more than 3,000,000	575	625	1200	2500				
	700	800	1300	6000				

Additional Usage	Add to or Deduct from Original Fee	
Double page: (spread) (additional % of Full Page fee)	100 %	%
Back/Inside cover: (less % of Cover fee)	35 %	%

Rights: Reuse after 1 year (depends upon usage)
 Exclusive (depends upon usage)
 Unlimited (depends upon usage)
 Buyout/All Rights (depends upon usage)

● ● ● ● ●

STOCK PRICES – EDITORIAL

MAGAZINES – DUMMY

Base Fee: one time, non-exclusive	¼ Page	½ Page	Full Page	Cover		¼ Page	½ Page	Full Page	Cover
Copies Printed									
	$ 100	$ 150	$ 200	$ 400					
1	125	175	250	500		$ ___	$ ___	$ ___	$ ___
	150	200	300	575					
	150	200	250	500					
1 - 250	200	250	300	575		___	___	___	___
	250	300	375	625					
	200	250	300	600					
more than 250	250	300	375	700		___	___	___	___
	300	350	425	800					

Additional Usage	Add to or Deduct from Original Fee	
Double page: (spread) (additional % of Full Page fee)	100 %	___ %
Back/Inside cover: (less % of Cover fee)	35 %	___ %

Rights: Reuse after 1 year (depends upon usage)
Exclusive (depends upon usage)
Unlimited (depends upon usage)
Buyout/All Rights (depends upon usage)

STOCK PRICES – EDITORIAL

MISCELLANEOUS

Base Fee: one time, non-exclusive	FLAT FEE	% of Normal Fee	FLAT FEE	% of Normal Fee
Artist Reference (*1)	$ 150 200 272	75	$ ☐	$ ☐
Art Rendering (*2)		75	☐	☐
Presentation/Layout (*3)	175 200 250		☐	☐

Additional Usage: Not applicable – usage for the above is one time only

(*1) use of a photograph, by an artist, for technical and/or detail reference. The resultant artwork will not be so complete as to render the photograph as recognizable within the artwork

(*2) use of a photograph, by an artist, to produce a recognizable rendition. The fee charged may be a percentage of the normal fee. See category of use where work will appear and charge a percentage depending upon how it may be used.

(*3) use of a photograph for presentation for approval. Reproduction rights, beyond this use, are not granted. If photograph is used in advertising, see appropriate Advertising category for usage fee.

STOCK PRICES – EDITORIAL

MULTIMEDIA/AUDIO VISUAL (non-commercial, in-house use only)

Base Fee: one time, non-exclusive	**1 Showing**	**1 Showing**
Slide Show Images	(per photo)	(per photo)
	$ 200	
1	250	$ ____
	275	
	175	
2 - 25	200	____
	250	
	150	
25 - 100	175	____
	200	
	100	
more than 100	125	____
	150	
Stills in Filmstrips/Video		
	175	
1	200	____
	225	

Additional Usage	**Add to Original Fee**	
Showings: 2 - 10	25 %	____ %
more than 10	75 %	____ %
up to 1 year	100 %	____ %
Additional images (filmstrips/video) 2 - 10	25 %	____ %
more than 10	75 %	____ %

Rights:	Reuse after 1 year	(depends upon usage)
	Exclusive	(depends upon usage)
	Unlimited	(depends upon usage)
	Buyout/All Rights	(depends upon usage)

104

•••••

STOCK PRICES – EDITORIAL

NEWSPAPERS

Base Fee: one time, non-exclusive	¼ Page	½ Page	Full Page	Cover	¼ Page	½ Page	Full Page	Cover
Circulation —Daily								
	$ 225	$ 250	$ 300	$ 600				
under 100,000	250	300	350	650	$	$	$	$
	275	350	400	700				
	250	325	500	650				
100,000 - 500,000	275	375	550	700				
	300	400	600	750				
	300	400	600	800				
over 500,000	325	425	650	850				
	375	450	700	900				
Sunday Supplements								
	300	350	500	850				
under - 1,000,000	350	400	600	900				
	400	450	700	950				
	350	400	600	1100				
1,000,000 - 3,000,000	400	475	700	1175				
	425	525	800	1275				
	400	450	800	1325				
over - 3,000,000	450	500	900	1350				
	500	550	975	1400				

Additional Usage	Add to Original Fee
Double page (additional % of full page fee)	125 %

 [] %

Rights: Reuse after 1 year (depends upon usage)
Exclusive (depends upon usage)
Unlimited (depends upon usage)
Buyout/All Rights (depends upon usage)

105

STOCK PRICES – EDITORIAL

RECORDINGS – EDUCATIONAL

Base Fee: one time, non-exclusive

	Tapes/CD's/Laser Disk	Tapes/CD's/Laser Disk
Back Cover	$ 500	$
	750	
	1050	
Front Cover	700	
	1150	
	1450	
Wrap–around cover	1000	
	1500	
	1700	
Enclosures	300	
	400	
	500	

Additional Usage	Add to or Deduct from Original Fee	
Tests	Deduct 60 %	___ %
Usage on both tape and CD	50 %	___ %

Rights: Reuse after 1 year (depends upon usage)
Exclusive (depends upon usage)
Unlimited (depends upon usage)
Buyout/All Rights (depends upon usage)

STOCK PRICES – EDITORIAL

TELEVISION

Base Fee: one time (or a specific period), non-exclusive	Local	Regional	National	Local	Regional	National
Area of coverage						
	$ 225	$ 275	$ 350			
Editorial use	250	300	400	$	$	$
	300	350	500			

Months of usage*	less than 2	2–6	more than 6			
	200	400	600			
Background editorial	250	500	700	$	$	$
	300	600	800			

Additional Usage

Rights: Reuse after 1 year (depends upon usage)
Exclusive (depends upon usage)
Unlimited (depends upon usage)
Buyout/All Rights (depends upon usage)

*** Editorial use is usually one time; if usage is for a period of time make sure that it is for editorial use, if for advertising or promotion (especially for station promo) see Advertising.**

STOCK PRICES – MISCELLANEOUS

AUDIO VISUAL

Base Fee: one time, non-exclusive

Number of Images – Slide show	1 Showing (per photo)	1 Showing (per photo)
1	$ 200 / 250 / 275	$ _____
2 - 25	175 / 200 / 250	_____
25 - 100	150 / 175 / 200	_____
Over 100	100 / 125 / 150	_____
Stills in Filmstrips/Video		
1	175 / 200 / 225	_____

Additional Usage	Add to Original Fee	
Shows 2 - 10	25 %	____ %
more than 10	75 %	____ %
up to 1 year	100 %	____ %
Additional images (filmstrips/Video) 2 - 10	25 %	____ %
more than 10	75 %	____ %

Rights: Reuse after 1 year (depends upon usage)
 Exclusive (depends upon usage)
 Unlimited (depends upon usage)
 Buyout/All Rights (depends upon usage)

STOCK PRICES – MISCELLANEOUS

CALENDAR*

Base Fee: one time, non-exclusive	**Insert Photo**	**Main Photo**	**Insert Photo**	**Main Photo**
Distribution	(per photo)	(per photo)		
Single Hanger	$ 500	$ 800		
less than 50,000	700	1200	$ ⬚	$ ⬚
	800	1500		
	800	1600		
more than 50,000	850	1900	⬚	⬚
	900	2300		
Multi-sheet: 12 months				
	450	800		
less than 50,000	600	1075	⬚	⬚
	750	1200		
	650	1300		
more than 50,000	800	1850	⬚	⬚
	1050	2100		
Multi-sheet: 52 weeks				
	400	450		
less than 50,000	500	600	⬚	⬚
	600	950		
	500	800		
more than 50,000	700	950	⬚	⬚
	800	1200		

Additional Usage

Royalties: after a press run of 50,000 copies add the following; cents per calendar promotional $0.50 ⬚
 resale $0.75 ⬚

Rights: Reuse after 1 year (depends upon usage) Unlimited (depends upon usage)
 Exclusive (depends upon usage) Buyout/All Rights (depends upon usage)

*** if sold, royalty fees may apply. Also see Calendar in Advertising and Corporate**

109

STOCK PRICES – MISCELLANEOUS

CARDS – GREETING & POST

Base Fee: one time, non-exclusive	Fee *	Fee*
Greeting Cards		
	$ 575	
Retail sale	700	$
	800	
	800	
Advertising or promotional use	900	
(or see Advertising-brochure rates)	1000	
Postcards		
	600	
Retail sale	700	
	800	
	800	
Advertising or promotional use	900	
(or see Advertising-brochure rates)	1000	

Additional Usage

Royalties: after a press run of 10,000 copies add the following cents per card: promotional $0.10

resale $0.50

Rights: Reuse after 1 year (depends upon usage)
Exclusive (depends upon usage)
Unlimited (depends upon usage)
Buyout/All Rights (depends upon usage)

*** Press run, Distribution and Translation Rights requests will affect Fees significantly.**

STOCK PRICES – MISCELLANEOUS

CD-ROM DISK – CONSUMER* (retail sale)

Base Fee: one time, non-exclusive	1-10 Images	10-50 Images	50-100 Images	over 100 Images	1-10 Images	10-50 Images	50-100 Images	over 100 Images
Number of Pressings	(all per photo)				(all per photo)			
	$ 400	$ 300	$ 250	$ 200				
less than 10,000	475	350	300	250	$ ____	$ ____	$ ____	$ ____
	500	400	375	300				
	500	375	350	275				
10,000 - 50,000	550	450	400	325	____	____	____	____
	600	500	450	375				
	600	525	400	300				
more than 50,000	675	575	450	400	____	____	____	____
	700	600	525	475				
Test pressing								
	350	275	250	200				
less than 1,000	400	350	300	275	____	____	____	____
	450	400	325	300				

Additional Usage

Royalties: after a press run of _____ copies add the following; cents per disk promotional $0.00 [____]
resale $0.00 [____]

Rights: Reuse after 1 year (depends upon usage)
Exclusive (depends upon usage)
Unlimited (depends upon usage)
Buyout/All Rights (depends upon usage)

* to date there have been few reported sales in this area

** there were no reported royalty arrangements, however, it is something that should be considered (see Chapter 2- The Mysteries of the Future).

STOCK PRICES – MISCELLANEOUS

DISPLAY PRINTS (Framed reproduction 16x20)

Base Fee: one time, non-exclusive	**Press Run Fee***	**% of Retail****	**Fee**	**Press Run Fee***	**% of Retail****	**Fee**
Reproduction Press Run						
Less than 5,000	$ 500 800 1000	10		$ ☐	☐	
5,000 - 25,000	750 1200 1700	15		☐	☐	
more than 25,000	1500 2000 2400	20		☐	☐	
Murals – Length of Display (24x30 or larger)						
up to 6 months			800 1200 1600			☐
up to 1 year (longer periods to be negotiated)			1200 2000 2400			☐

Additional Usage	**Add to or Deduct from Original Fee**	
Educational study prints	Deduct 25 %	☐ %
Print size (not murals): smaller than 16x20	Deduct 25 %	☐ %
larger than 16x20	50 %	☐ %

Royalties: after a press run of 10,000 copies add the following; cents per piece promotional $1.00 ☐
resale $0.75 ☐

Rights: Reuse after 1 year (depends upon usage) Unlimited (depends upon usage)
Exclusive (depends upon usage) Buyout/All Rights (depends upon usage)

*** If pricing by size of Press Run, also think about royalties**

**** If pricing by charging a percentage of the retail sales price be aware that items will be frequently and drastically discounted**

• • • •

STOCK PRICES - MISCELLANEOUS

POSTERS - RETAIL*

Base Fee: one time, non-exclusive	US	World	US	World
Press Run: 16 x 20				
	$ 650	$ 800		
less than 5,000	700	900	$ []	$ []
	775	1250		
	800	1000		
5,000 - 25,000	950	1200	[]	[]
	1050	1500		
	1025	1250		
more than 25,000	1100	1325	[]	[]
	1200	1750		

Additional Usage	Add to or Deduct from Original Fee
Print Size:	
smaller than 16 x 20	Deduct 20 % [] %
larger than 16 x 20	25 % [] %

Royalties: after a press run of 10,000 copies add the following cents per poster: $0.75 []

Rights: Reuse after 1 year (depends upon usage)
Exclusive (depends upon usage)
Unlimited (depends upon usage)
Buyout/All Rights (depends upon usage)

113

* These posters are for retail sale; although they may also promote or advertise a product or service the intention is to realize profit through sales. Be sure that you understand the main purpose- sales versus promotion- before you come to an agreement. If for promotional or advertising use, see Advertising or Corporate.

● ● ● ● ●

STOCK PRICES – MISCELLANEOUS

RECORDINGS – RETAIL (Tapes/CD's/Laser Disk)

Base Fee: one time, non-exclusive*

Press Run	Back	Front	Wrap Around	Back	Front	Wrap Around
less than 5,000	$ 600	$ 950	$ 1000	$ ____	$ ____	$ ____
	675	1075	1150			
	750	1200	1250			
5,000 - 10,000	700	1275	1200			
	750	1400	1475	____	____	____
	825	1550	1700			
10,000 - 20,000	1025	1600	1800			
	1225	1750	1900	____	____	____
	1300	1825	2000			

Additional Usage	Add to or Deduct from Original Fee	
Tests (very small runs only)	Deduct 50 %	____ %
Usage on both tape and CD	50 %	____ %

Royalties:** after a press run of _____ copies add the following; cents per poster $0.00 ____

Rights: Reuse after 1 year (depends upon usage)
 Exclusive (depends upon usage)
 Unlimited (depends upon usage)
 Buyout/All Rights (depends upon usage)

*** Price heavily dependent upon: print run, shelf life of product, retail price per unit, whether or not recording artist is a major name, as well as the other, usual, Pricing Factors**

**** Number reporting was too low for accuracy**

STOCK PRICES – MISCELLANEOUS

Base Fee: one time, non-exclusive	Fee*	Basis**	Fee*	Basis**
Apparel-shirts, bags	$ 650	_____	$	$
Background-movies, TV	1200	_____		
Bank checks	900	_____		
Credit cards	1200	_____		
Life size personalities	1000	_____		
Logo (corporate)	1500	_____		
Novelty-tags, etc	500	_____		
Phone book covers	1500-5000	_____		
Placc mats	600	_____		
Plates-mugs, etc	600	_____		
Playing cards	550	_____		
Puzzles	750	_____		
Stamps	1000	_____		
Stationery	600	_____		
Other	_____	_____		

Additional Usage

Royalties:* after a press run of _____ copies add the following; cents per item promotional $0.00

resale $0.00

Rights: Reuse after 1 year (depends upon usage) | Unlimited (depends upon usage)

Exclusive (depends upon usage) | Buyout/All Rights (depends upon usage)

115

* **Be aware that prices for these usage categories varies widely, depending upon the scope of the project, uniqueness of the photo, and other Pricing Factors.**

** **Basis is the predominent factor price is based on: press run, number of times used, etc**

*** **Not enough data was collected for accuracy.**

● ● ● ● ●

Chapter 10

Buyer's Guide

T here are no secrets in this book. The information and advice presented to photographers is either common sense or established industry practice. And, if you have skimmed this book you know that most of the advice, with a slight turn of angle, is also applicable to you as a buyer of photography. Your goal is virtually the same as that of the photographer, a good photograph that suits your purpose, on time and at a fair price. The purpose of this chapter is to highlight the ways you can help make that happen.

Buying Photography

In the hands of a creative person buying photography is an art in itself. Matching the right photographer to a project or knowing the best source for a particular style of stock photography results in the brilliant ad campaigns or stunning magazine articles that dazzle us all. It's how reputations are made. The pedestrian way of merely finding a picture, any picture, at the lowest price, usually ends up

as a waste of money. A mundane approach brings a mundane result.

Photography is bought by almost everyone from a top art director, photo editor, or art buyer to the greenest assistant or, sometimes, even a secretary.

If you're new to the business, you may not be aware that the term "buying" photography is not accurate but merely the colloquial term used in the industry. Rather than buying photographs, you are actually obtaining a license or grant of use, which allows you to use a specific photograph in a stipulated way. There's more on this in chapter 1, throughout the book and in the discussion of rights later in this chapter.

Having the Information

Be armed before starting out, not to vanquish, but to get the most from your photographer. Know what you want and why.

Have courage. If you are down the line of command and don't have access to all the information about a photography project, insist that your bosses take the time to clarify their needs. (After all, mind reading wasn't on your job description.) Let them know that you can get them what they want, only if you know what they want. Ask them the same questions that a photographer or stock agent will ask you. Posing these questions helps make sure that the creative person requesting the photograph has made their internal vision clear to you. When they understand why you need the information your questions will seem helpful rather than pestering. The art director who doesn't have time to clarify for you now, may spend double the time in extra research later on. And, if you're the one intitiating the photo search, the same clarity is essential.

The more you involve the stock agent or photographer in a photo request the better the results will be. They're human, and they're professionals, like you. They enjoy a challenge and they can do much more than merely process pictures. The more information you share with your source, the more creative their suggestions will be.

•••••

If they, and you, don't understand the purpose of the photo you won't be able to find the very best picture for the purpose. Listen to this scenario:

Ad agency Art Director to their Photo Researcher:

"Get me a dynamite shot of the Grand Canyon."

Photo Researcher to Stock Agent:

"I need a dynamite shot of the Grand Canyon."

Stock Agent to Photo Researcher:

"Happy to help. What is your concept? What exactly about the Grand Canyon are you trying to show?"

Photo Researcher to Stock Agent:

"Well, that doesn't matter. We just need a great shot. But you know, it's odd that I haven't been able to find the right thing with all the pictures of the Grand Canyon around. I just can't seem to please my art director.... I'm in a bind. Find me something wonderful."

Stock Agent:

"I'd like to, but I really need to know what you are trying to say with it. Is it to show the grandeur of nature? The romance of travel? What does the copy say?"

Photo Researcher:

"Well, actually it's for an investment firm ad to go with a headline "Don't throw your money into a hole in the ground." And the Grand Canyon is the biggest hole there is, right?"

Stock Agent:

"Ahaa, that helps. Let me look some more. It actually wouldn't have to be the Grand Canyon if it looks like a big hole, right?"

The final photo used was a dramatic angle in Bryce Canyon. Case closed.

In addition to the specifics, know your priorities for a photograph. It's easy to say the photo has to be brilliant, unique, fresh, exclusive, and cheap. But pie in the sky isn't a category so easily filled. Have a realistic view of your priorities before making a photo request or discussing an assignment. Which element is of paramount importance: the graphic impact of the photograph, the emotional content of the photograph, the schedule, the budget, the style, the freshness of the image?

If you bring in the wrong photo you'll find out fast enough what the art director's priorities were.

Be as clear as possible. Give a photographer or stock agent as much information as you have. Holding back seldom pays, and it could waste your time or cost you more later on. Some people hold the misguided notion that you will be taken advantage of if you divulge information. By sharing information you'll get not only better results from a photographer but probably also get some extra ideas in the bargain.

Stock or Assignment—Choosing What's Best for You

Circumstances may dictate which route you'll take when looking for photography. If you need a still life including the logo of your client's product, or an executive portrait in front of a newly constructed facility or a picture story on the newest New Age guru, then you'll have to assign the photography. When you need a photograph on a short deadline, or want a generic summer scene in the depths of winter, or have a committee of twelve who must sign off on the picture approval, or want to see a wide variety of creative approaches, then stock is probably the answer.

The choice between assignment and stock is not always clear cut and you'll need to weigh many factors, such as:

Risk: with stock there is none. You have it in hand. You get what you see. But an assignment has risk. There can be transportation delays, models who don't perform well, technical mishaps; almost anything can go wrong. Good photographers, however, know how to minimize those risks.

What You Need to Know Before Looking for Photography

Purpose of photo: Should it explain, illuminate, decorate, evoke mood, grab attention, serve as background...

Content of photo: your concept

Content of photo: literal subject matter—suggest the content to illustrate your concept but leave room for other ideas from photographer or stock agent.

Headline: tag line, copy, or caption

Shape: Horizontal, vertical, square, silhouette.

Film: Color or B&W.

Film Format: 35mm, 21/4, 4x5 (consult with photographer)

Layout or sketch: is one available?

Importance of these elements to you: style, originality, exclusivity

Market: Define your target audience (MTV generation, Boomers, Seniors?)

Market: Are you trying to emulate or be distinguished from your competitors?

Risk: the amount you want to take

Release needs for property or models: is it a sensitive issue; are they necessary for an ad or product endorsement?

Schedule: time available, deadline

Usage/ media type: ad, brochure, magazine, book, billboard

Usage/ position: back cover, front cover, interior

Size (how big): full page, 1/4 page

Insertions (how many times): 6, 10?

Duration (for how long): 2 years, 4?

Cost of media buy: space rate total or dollar amount

Budget range:

Expectations: Will all of the above achieve your goal?

What do you really want from this photograph?

All of this information, clearly articulated, will help you and the photographer or photo agent come up with the best photographic solution for you.

Approval: with stock, everyone knows in advance what the picture looks like, how well it works with the concept and in the layout. An assignment photo can be a pig in a poke. It may not come up to your imagined expectations or it may far exceed expectations when in the hands of a fine photographer.

Schedule: with stock, once you've found it, you've got it. There are no hold-ups. An assignment handled by a skilled professional will be done on time, but there are sometimes delays, like weather, beyond anyone's control. They should be factored into any assignment schedule.

Concept: when you are developing an idea you can benefit equally from working with an imaginative assignment photographer or a creative stock agent.

Freshness: an assignment will guarantee you a photograph that has never been published before, one that is unique to your project, tailor-made for your use. On an assignment you can take advantage of an exciting creative collaboration with the photographer or be the beneficiary of the magical unpredictability that can happen on a shoot, when things work even better than anyone imagined. That's the upside of risk.

Style: when style is a critical element, art buyers, in general, will search to find an assignment photographer with the right look or graphic approach for the project, then have that photographer craft the concept or subject matter using his or her unique vision. These days you can find a remarkable variety of up-to-date photographic styles in a stock agency. Though for truly fresh work an assignment, with all its risks, should be a strong consideration.

Market: The audience for your photograph may determine whether you choose stock or assignment for the style you need. If the target audience is the MTV generation you may choose an assignment photographer with a leading edge or experimental style, something that has not yet shown up in a stock agency. However, if your audience is the general public, there may be a wide variety of excellent imagery already available in stock.

Exclusivity: some, but not all, stock agencies have the sophisticated equipment to monitor usage and guarantee exclusivity. Be cautious. If exclusivity is essential, either you will be limited in your choice of agency or may need to assign the photography.

Releases: when setting up an assignment you can specify the release protection you need and make sure the photographer also turns in copies of the appropriate release for each person or any recognizable property in a photograph. Not all stock photos are released. Any reputable stock agency can tell you if a release is on file for a given photograph. They can also advise when a release is needed. Be sure to ask for a copy of a release, particularly if you intend to use a photograph in a sensitive context, such as tobacco or alcohol ads, or with implications of health problems or criminal activity, for example. However, a release will not necessarily protect you if there is a derogatory or defamatory use. For example, use of a released photo of a courtroom scene may or may not be advisable with a magazine article about medical malpractice. It can depend on the implications in the article, the relationship to the photograph, and the wording of the caption. Know the law regarding releases and libel (see the Bibliography).

Buying Assignment Photography

You can increase the likelihood of success on an assignment in dramatic ways if you work with your photographer in a spirit of partnership.

What may sound strange, at first, is that most professional photographers want you, their client, to get a very good deal just as much and perhaps more than they want it for themselves.

The keystone in a creative collaboration is the satisfaction the photographer gets from solving your joint needs, aesthetic and logistical. Carrying off a creative coup is fun. It feels good to do a good job. It feels even better when the person you're doing it for knows it and appreciates the effort.

How to get the best deal in assignments

Deals usually mean money. Considering money alone is shortsighted; there are many valuable, intangible extras that add to a "deal." A professional must be measured by what they deliver, not what they cost.

It costs more to patch up a botched job than to do it right the first time.

Time for a war story. A photographer, while courting a new client, learned that they had been getting a great "deal" for several years from another photographer. His work was good and the fee for all rights was really low but.... The photographer leaned forward, listening intently. They said there was only one problem, nothing was organized. Models didn't get paid, releases didn't match the photos, and worst of all, he was late.

When she heard the astoundingly low fee their favored photographer had been charging, our colleague ventured an explanation that one of two possibilities was likely: either the photographer was a terrible businessman and just didn't realize that he wasn't charging enough money to allow for a professional job, or he was shrewd, but unethical, in accepting a fee he knew to be deficient, then knowingly letting slip the aspects he couldn't afford to handle. She got the next assignment from these folks, with the fee at a professional level.

When you have a tight budget

To get a good financial deal, be clear and be fair. Explain what you need, what your limits are. On the occasions when you really have a tight budget (not the common garden variety "get it as cheap as you can" tight budget), one with true limitations, let the photographer help you formulate the budget and design the shoot to get the most for the money you have. By suggesting where and how to spend they can help make the most of a lean budget. A photo buyer may actually waste money, or worse, undermine the entire project by unilaterally slashing in the wrong places. Enlist the photographer's expertise. For example, the photographer may advise you that cutting out a stylist won't save enough to be worth the loss of quality, but that an extra set construction expense could be avoided by shooting from a different angle.

Getting the most for your money

Give support and appreciation. A photographer will walk across hot coals (if that should be of use to you) for a client who is constructive in criticism, unstinting in praise, and has a good sense of humor!

Professional photographers will give you an honorable job for the fee you pay, but often you can get much more than your money's worth from a photographer by treating them fairly and involving them in the process.

The extras a photographer can give are sometimes simply an intangible pushing of the limits. A more concrete instance is when they continue to work past the limits of the assignment. Consider the tired photographer heading to the airport, the morning after a grueling two-day corporate shoot, who looks back and sees spectacular light on the facility and the wetlands nearby, stops, gets some terrific shots, and has to hustle to make the plane. Technically the photos are not part of the assignment, but our well-treated photographer includes them in the edit. The wetlands pictures are a bonus to the corporation, and the result of having a fair and open relationship with the photographer.

In a few cases photographers have found it a double-edged sword to offer something extra. They have had clients tell them not to waste film on a subject they didn't request. That certainly appears to be a squashing of creative initiative, but if you don't want anything beyond the limits of the assignment, make that clear to your photographer in the beginning.

On the other side of the coin, if you have a photographer who is giving more than full measure, be careful. Don't drive them to the point of exhaustion. Over using their good will and obsessive dedication to work can lead to a point of diminishing return.

How do I protect my investment?

Some buyers attempt to buy all rights to an assignment, or many more rights than they need, out of fear that photos from their assignment will show up in a competitor's materials. That's easy to avoid by working with the photographer to develop protective restrictions and time limits, perhaps like paying for exclusive usage for an appropriate time period. It shouldn't come as a shock to you to know that photographers want your assignment to be protected as much as you do.

By investing in an assignment instead of using available stock you are making the opportunity for them to create new work. Being a professional means more than talent and skill, it means ethical and honorable dealings as well. Protecting your assignment is not only the hallmark of a professional, it's enlightened self-interest. Professionals certainly don't want to jeopardize the faith you have in the assignment process or in them. It's also why professionals must insist on a sufficient fee to cover all the extra protection that you have a right to expect.

What do I get for my money?

Or, "If I pay for it why don't I own everything?"

On an assignment you get whatever rights, time limits, and protective restrictions you have negotiated with the photographer.

It's dangerous to make assumptions, on either side, about what rights are being granted or obtained. You and the photographer must have a clear agreement and it should be in writing.

"But still, if I pay for it why don't I own it?"

Just because you paid for someone's time doesn't necessarily mean you own them. When you rent a car you don't expect to own it. So, too, with a photograph, which is comprised of a bundle of rights, you are granted the ones you need, for as long as you need them.

"But I pay all the expenses."

Yes, and you get extra benefits for that investment which include first use, time limit exclusivity, and protection from competition, benefits that may not come with stock.

Buying Stock Photography

Buying rights to stock photography can be relatively straightforward when you work with the many reputable stock agencies and stock photographers. But there are ways to increase the efficacy of your stock buying, and there are pitfalls to be avoided.

For this discussion, references to stock "sources" will be assumed to include photographers selling stock as well as stock agencies. Though sometimes on a different scale, individual photographers offer the same services and bear many of the same costs as a stock agency, so the comments in this chapter apply equally to both.

How to get the best deal in stock

Although it may not seem to be necessary to say, establish a good working relationship with your stock sources. Treat them, the photographs, and the service they offer with respect and you'll reap great rewards. You can build good will with an agency if you:

Don't shop just for the sake of it. Be serious about your requests. Though you may pay a research fee for the privilege of viewing a selection, this fee is a token and covers only a very small portion of the cost of providing a stock submission. An agency would much prefer to have the photographs on file, available for a serious client, in place of any research fee. If you have no choice but to search for ideas, say so, be straight about it. Let them know you're not sure what you need. They'll help.

Don't set unrealistic or unnecessarily tight deadlines. We all know what happens when wolf is cried too often.

Don't hold photographs longer than needed, or without notifying the source. An agency doesn't like to charge holding fees. It's another symbolic fee but doesn't touch the cost of not having the pictures available for sale. What's not in the file can't be sold. So return immediately what you don't need. Speedy first returns will endear you to a stock source and ensure great service the next time you have an emergency.

Give preference to the sources that are most responsive. A stock agent doesn't assume that they are your only source, but in the event that you have a favorite source or two (whether photographer or agency), let them know when you are giving them a first crack at your request.

As with assignments, good deals in stock don't always mean money. Good service can be more valuable than a low reproduction fee when you're in a tight spot and the agent you've built a relationship with comes through for you.

Getting the most for your money in stock

You are getting the best bargain in the business even if you pay the top fee currently charged by a source. That's because stock reproduction fees, as well as assignment fees, have lagged way behind the dramatic increases in photography costs over the past fifteen to twenty years. Fees have barely changed for over a decade while costs to produce photography have soared. Stock already gives you risk-free photography at an excellent price.

OK, fine, but now how can I save money? One way is to negotiate at the outset all the uses you envision over a period of time. An agency is usually more inclined to give a discount when you buy a package of rights.

That brings us to the sticky subject of volume discounts. It makes sense that a source will offer a break when you use many photographs from their collection.

For an agency, discounts can be problematic. They want to give some benefit to a client who buys a lot, but can't do it at the expense of the individual photographers who may only have one photo included in a deal. They must provide their contributing photographers sufficient income to allow reinvestment in new work or else the flow of quality photography you demand will dry up.

What do I get for my money?

You get an extraordinary selection of excellent images by the world's leading photographers, immediately. Often overnight you'll have top quality photographs on your lightbox, ready for review.

In order to offer the immediate service you need on a deadline, stock agencies and stock photographers must maintain sophisticated and expensive computer tracking systems. They keep records on exclusivity, model release files, and caption information.

With some agencies you can negotiate exclusivity on specific photographs for an extra fee.

Should I pay full fee to an individual photographer?

After all, they only get half from their agency anyway.

When you pay a stock fee it covers your usage whether for a magazine article, a point of purchase ad, or a greeting card. Your usage is no different when you get the photograph from an individual photographer. It serves your purpose or it doesn't, regardless of source.

You are also getting backup services from the source providing those images. It must not be assumed that a photographer can afford to charge less since they are providing not only the same usage rights but also most of the same service an agency would for the image you need. Individual stock photographers have overhead and service costs to maintain filing systems, process your submissions, and cover promotion and advertising in source books and catalogs, to name a few. Many have also invested in top end computer systems with imaging capabilities.

To compete with a stock agency for your business, today's individual stock photographers must offer a level of quality and service that is very expensive and requires full fee to maintain.

Copyright

As you saw in chapter 1, copyright is the right to control all uses of the image. Congress, through the Federal Copyright Law, gave (independent, non employee) creators the control of the tangible results of their efforts, whether commissioned by a client or done on their own time. The non employee photographer owns the copyright from the moment the shutter clicks, and that copyright remains with

the photographer unless it is transferred in writing, usually called a license to reproduce. It is well worth reading more about copyright in the books suggested in the Bibliography.

Note: an idea cannot be copyrighted. Only the tangible expression of that idea, the resulting photograph (or sculpture, illustration, novel etc.), can be copyrighted.

Copyright infringement—
I have this picture, can you shoot one like it?

Imagine this situation: The art director at your agency comes to you with a photograph clipped out of a magazine and says: "This is an interesting shot, it'll work for our XZY campaign. Get Charlie Cheap to shoot it for us. Do the same thing, just change it around a bit." Any problems? Yes, you would probably be guilty of infringement of copyright. It's against the law to take anything that you don't own the rights to and copy it, even with some modification. It's not always clear cut when an infringement has occurred, but "substantially similar" is the phrase in the law and a measuring stick for a judge or jury to use when deciding if infringement has occurred. There are many articles in the trade press about copyright infringement. It's smart to stay informed and to know the current legal cases.

The way out, instead of copying, is to find the person who took the shot you like so much and negotiate with them for the rights needed on your campaign. If the photograph is not available due to competitive restrictions, talk with the photographer of the original shot (you liked their lighting, composition, creative approach, right?) about creating a different photograph to suit your needs. You'll benefit by getting a fresh photograph and be well clear of dangerous infringement waters as well.

Digital infringements
Current and imminent computer capabilities make merging many photographs into a seamless new image a reality, and make infringement difficult to detect. There is no body of case law regarding this new type of potential abuse of copyright. What's important to understand, especially for newcomers to the field, is that merging parts of images into a new whole without the permission of **all** copyright owners is illegal, no matter how difficult to detect.

One reason will prevent art directors from pirating images now, just as it has in the past, regardless of ease. And that is, because it is dishonorable. Truly professional, creative, people don't pirate in order to be successful.

Work for Hire— And why you don't really need it!
It costs too much. That's the number one reason. You are, in effect, buying the whole pie when you may need only a few slices. (See chapter 1 for an explanation of work for hire.)

Also, it discourages the very best photographers from working with you. A creative, innovative photographer has enough respect for their work to want to keep the copyright. Just think, by asking for work for hire, you, as the client, become the creator as if the photographer never existed. The photographer loses all control over the image for all time, including the ability to show the work in a portfolio, gallery show, or retrospective. The tangible expression of their life's work is gone. It's a serious matter to a creative person and it can be a major detriment to their economic survival.

Few of you, photographers' clients, who ask for work for hire, really need it, and most of you are simply doing so out of convenience, because you won't have to bother thinking about usage again, now or later. In actuality, you really don't need to own everything; there is a less expensive way.

The best way to get the protection that some clients believe they achieve with work for hire is to negotiate up front exactly what they need, think they might need or even suspect they might need

later. The wise negotiator doesn't try to control or own everything through intimidation (in this case, "do work for hire, or you don't get the job"), rather they try to achieve a mutually agreeable resolution.

Perceptions— Why do photographers charge so much?
There is a perception among some photo buyers that "photographers charge a fortune" and that they must therefore make a fortune.

At first glance, from the point of view of a salaried employee, some confusion about costs and earnings is understandable. It can look as if a photographer earns more in one day than the art buyer does in a week. If you multiply that by fifty weeks a year the result appears to be the wealth of Croesus.

Unfortunately, the photographer does not earn a "salary" of that level. Experienced buyers know that a photographer's Creative Fee covers much more than their time. Look in chapter 2 for an idea of some of the typical photographer's overhead costs necessarily incurred in the running of a photography business. In addition to talent, a photographer is expected by you, the client, to have available sophisticated equipment which costs thousands of dollars to purchase and maintain, just to be ready for the day you call.

Photography fees reflect the cost of being in business, not the photographer's salary.

Building a Relationship

At the very least, a professional relationship should be productive and cordial. In the best of situations, photographers and clients become friends, people of like interests working together to solve a creative problem and enjoying the process.

Professionalism on both sides is a given. Loyalty, which is the outcome of understanding, mutual respect and fair dealings, may be the most valuable ingredient to foster in the relationship between photographer and client.

124

Evaluating an Assignment Photographer

In the process of hiring an assignment photographer portfolio samples are only the first step, and price shouldn't be the second. The professionalism of the person chosen to handle your work will be the key to the success of a project.

Use careful research, astute observation, and assessment to make sure you select based on the following abilities:

Creativity: judge by portfolio samples and promotion pieces... judge also by imagination shown in discussions about a potential assignment.

Technical ability: judge by portfolio samples and promotion pieces... also by technical solutions and suggestions in discussions about the problems of a shoot.

Equipment available: ask about the range of equipment a photographer uses and has available.

Professional business practices: judge by use of detailed forms and paperwork, knowledge of photographic law, model releases, property releases.

Problem solving/logistical planning: finding locations, set design, transportation, interpreters.

Management: of assistants, stylists... also budget, schedule.

Intelligence: being informed on issues.

Dependability: are there many repeat clients in the portfolio?

Good nature/pleasant manner: will this person represent you and your client well, and be easy to work with on a job?

Energy/enthusiasm: keep your ear tuned to recognize genuine excitement about your project.

If all of these attributes are positive, then your money is well spent with your chosen photographer.

Bibliography

ASMP (The American Society of Media Photographers). *ASMP Professional Business Practices in Photography*, Fourth edition. New York: ASMP, 1986.

ASMP (The American Society of Media Photographers). *ASMP Stock Photography Handbook*, Second edition. New York: ASMP, 1990.

ASMP (The American Society of Media Photographers). *ASMP Assignment Photography Monograph*, First edition. New York: ASMP, 1991.

ASMP (The American Society of Media Photographers). *Forms—ASMP White Paper*. New York: ASMP, 1989.

Crawford, Tad. *Business and Legal Forms for Photographers*. New York: Allworth Press, 1991.

Crawford, Tad. *Legal Guide For The Visual Artist*. New York: Allworth Press, 1989.

Crawford, Tad, and Kopelman, Arie. *Selling Your Photography*. New York: St. Martin's Press, 1980.

Gordon, Elliott and Barbara. *How To Sell Your Photographs and Illustrations*. New York: Allworth Press, 1989.

Heron, Michal. *How to Shoot Stock Photos That Sell*. New York: Allworth Press, 1990.

Heron, Michal. *Stock Photo Forms*. New York: Allworth Press, 1992.

Jacobs, Lou, Jr. *Selling Photographs:* Determining Your Rates and Understanding Your Rights. New York: Amphoto, 1988.

Lawrence, Peter and Cason, Jeff. *The Photo Marketing Handbook.* New York: Images Press, 1991.

Photo District News. Newspaper for professional photographers. New York: Visions Unlimited Corp., (monthly).

Photographer's Market 1993. Cincinnati: Writer's Digest Books,

Pickerell, James H. *Negotiating Stock Photo Prices*. Diamond Bar, California: Pickerell Marketing, 1989.

Pickerell, James H. *Taking Stock*. Monthly newsletter.

Piscopo, Maria. *Photographer's Guide To Marketing and Self Promotion*. Cincinnati: Writer's Digest Books, 1987.

Piscopo, Maria. *How To Get Paid What You Are Worth*. Newport Beach, California: Turner Video Communications, videotape.

Remer, Michael D. and ASMP (The American Society of Media Photographers). *Valuation of Lost Transparencies*. New York: ASMP, 1992.

Seed, Brian. *Stock Photo Report*. Skokie, Illinois, Monthly newsletter.

Standard Rate & Data, Co. *Standard Rate & Data* (Red Book). Wilmette, Illinois: Standard Rate & Date, Co., periodical.

Index

ALLWORTH BOOKS

Allworth Press publishes quality books for photographers, artists, authors, graphic designers, illustrators, and small businesses. Titles published include:

Business and Legal Forms for Photographers *by Tad Crawford*
Twenty-four essential forms covering all aspects of photography, plus careful explanations and negotiation checklists. "A simple one sentence review: Every photographer needs this book." —Shutterbug. (208 pages, 8 1/2" X 11", $18.95; Disk version in WordPerfect 5.1 format for IBM and compatibles or 2.0 for the Mac, forms only; $14.95, specify IBM or Mac)

Caring for Your Art *by Jill Snyder*
Step-by-step guidance on the best methods to store, handle, mount and frame, display, document and inventory, photograph, pack, transport, insure, and secure art. (176 pages, 6" X 9", $14.95)

How to Sell Your Photographs and Illustrations
by Elliott and Barbara Gordon
Two experienced reps tell who buys and how to reach them, creating your best portfolio, how to do promotion, pricing and negotiation, using reps, and more. (128 pages, 8" X 10", $16.95)

How to Shoot Stock Photos that Sell *by Michal Heron*
Everything you need to know for success as a stock shooter, from how to shoot to how to sell. Contains 25 unique self-assignments to let you create images that buyers want today. "One of the top publications in today's hottest photographic area." — Studio Photography (192 pages, 8" X 10", $16.95)

Legal Guide for the Visual Artist *by Tad Crawford*
This classic guide covers copyright, contracts, moral rights, privacy, leases, taxes, estate planning, and more, with valuable resource sections. (224 pages, 7" X 12", $18.95)

Make It Legal *by Lee Wilson*
This is the definitive guide to advertising, covering copyright, trademarks, libel, rights of publicity, and false advertising law. Includes model forms and releases. (272 pages, 6" X 9", $18.95)

Overexposure: Health Hazards in Photography
by Susan D. Shaw and Monona Rossol.
This highly acclaimed work offers a complete guide to all risks that photographers, lab personnel, and others using photographic chemicals face — and tells how to protect health and safety. (320 pages, 6 3/4" X 10", $18.95)

Stock Photo Forms *by Michal Heron*
Here are 19 forms that will organize your stock shoot and help you achieve success. Included are a stock job form, estimate for shoot expenses, a shooting day organizer, pocket releases, and more. A Main Selection of the Photography Book Club. (32 pages, 8 1/2" X 11", $8.95)

Protecting Your Rights and Increasing Your Income *by Tad Crawford*
This hour-long audio cassette covers copyright law (including the Supreme Court's work-for-hire decision and the test for infringement), and how to handle contracts and negotiations. (60 minutes, $12.95)

The Photographer's Organizer *by Michal Heron*
This unique guide will help all photographers who want to organize photographs, shoots, travel, resources, client lists, markets, and the business of photography. (32 pages, 8 1/2" X 11", $8.95)

The Photographer's Assistant: Learn the Inside Secrets of Professional Photography — and Get Paid for It *by John Kieffer*
The only book to explain how to break in as an assistant, needed skills, business practices, equipment and film, finding work, and more. Seven top photographers tell what they want in an assistant. A must for photographers who use assistants. (208 pages, 6 3/4" X 10", $16.95)

Travel Photography: A Complete Guide to How to Shoot and Sell
by Susan McCartney
This complete guide tells how to shoot the best possible photos — and earn money doing it. "Mandatory reading for all travel photographers," according to Bill Black, Picture Editor of Travel/Holiday Magazine. Includes ten self-assignments, world travel highlights, and releases in twenty-nine languages. (384 pages, 6 3/4" X 10", $22.95)

Please write to request our free catalog. If you wish to order a book, send your check or money order to:

Allworth Press, 10 East 23rd Street, Suite 400, New York, NY 10010.
To pay for shipping and handling, include $3 for the first book ordered and $1 for each additional book ($7 plus $1 if the order is from Canada). New York State residents must also add sales tax.